White Gold

Thomas Sayre

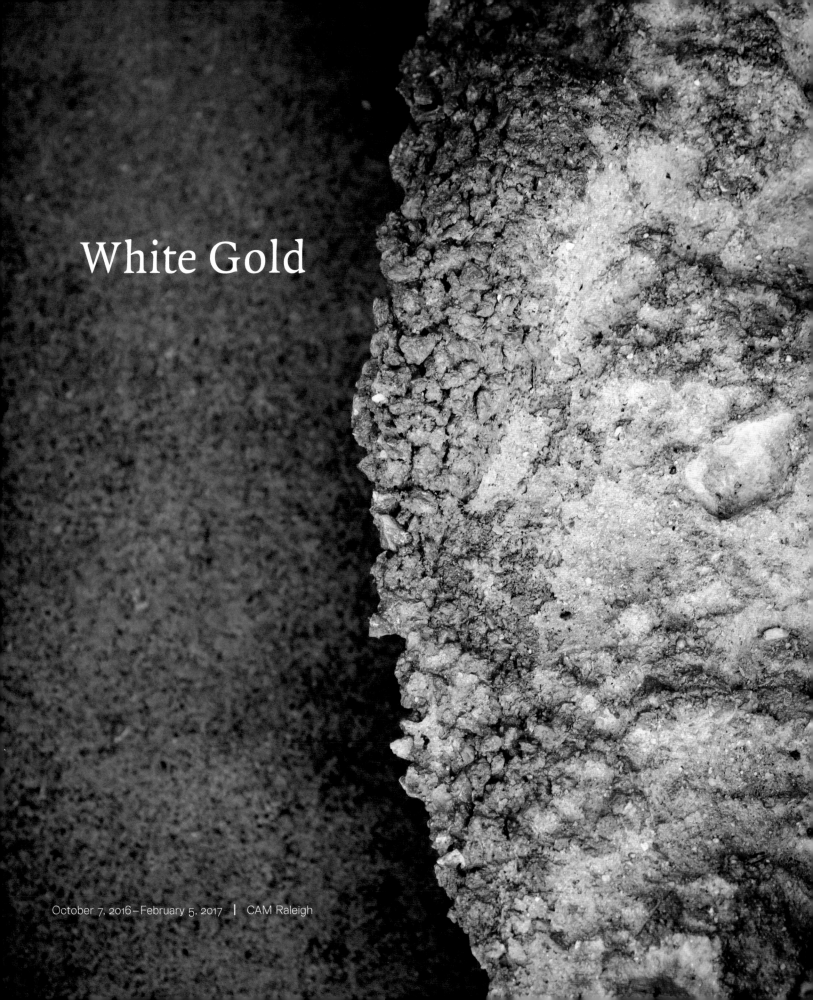

White Gold

October 7, 2016 – February 5, 2017 | CAM Raleigh

Mi Historia by David Dominguez reprinted with permission of the University of Arizona Press.

Voices poem commissioned from David Dominguez for the *White Gold* exhibition by CAM Raleigh.

Cotton, *Landscape*, *Dixie*, and *White Flower* poems and *Cotton Tales: Thanksgiving 2014* essay commissioned from Howard L. Craft for the *White Gold* exhibition by CAM Raleigh.

Thomas Sayre at CAM Raleigh commissioned from Deidre S. Greben for the *White Gold* exhibition by CAM Raleigh.

Lapsed Time commissioned from David Burris for the *White Gold* exhibition by CAM Raleigh.

ISBN: 978-0-9906909-2-4

A total of 500 copies of this hardcover first edition were published by CAM Raleigh in conjunction with the *White Gold* exhibition in December of 2016.

Randi Blank, copy editor

Edited, designed, and produced by Barbara Wiedemann at Design Story Works.

TABLE OF CONTENTS

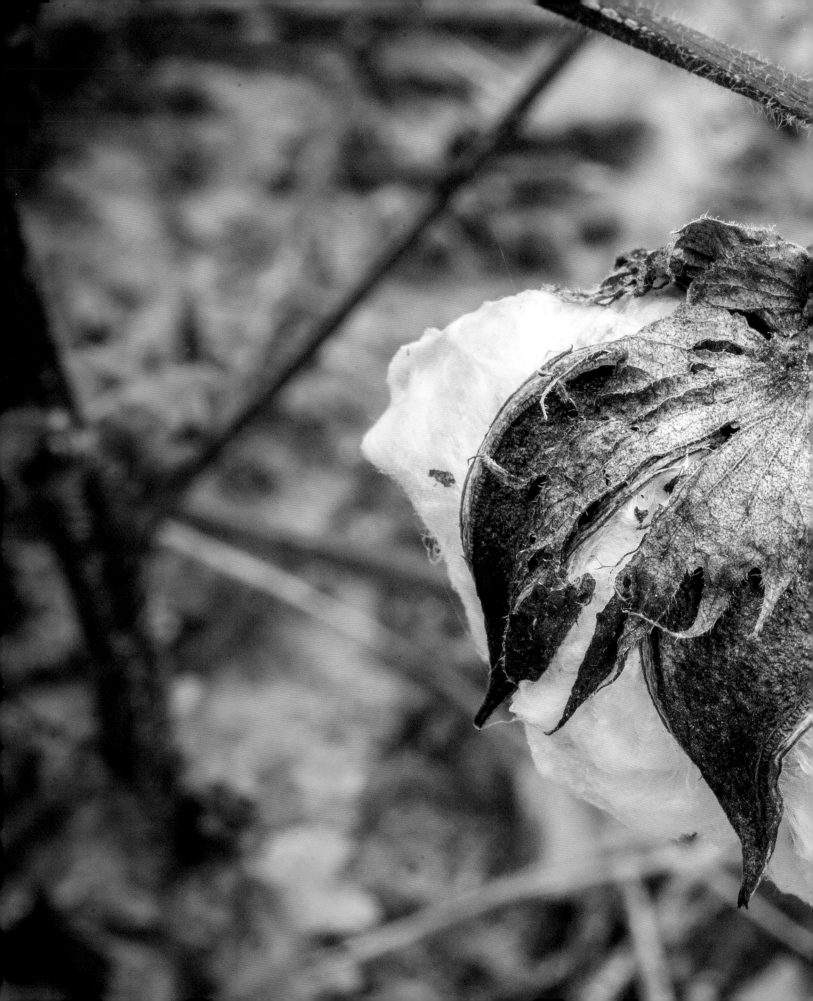

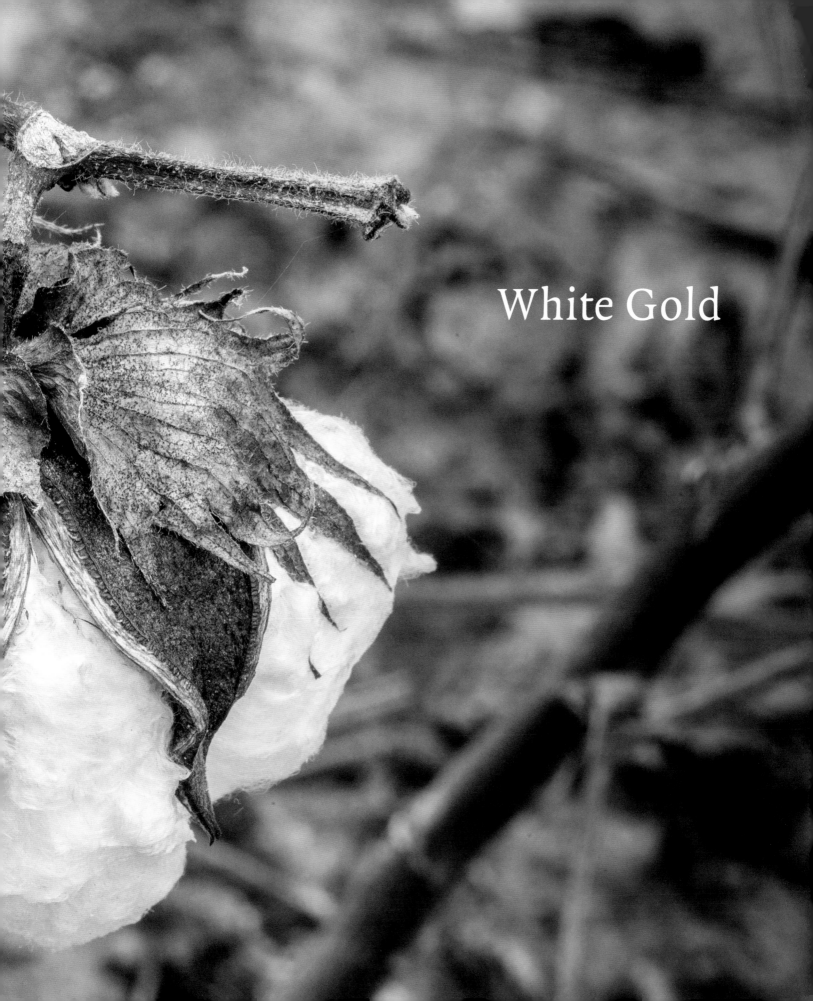

White Gold

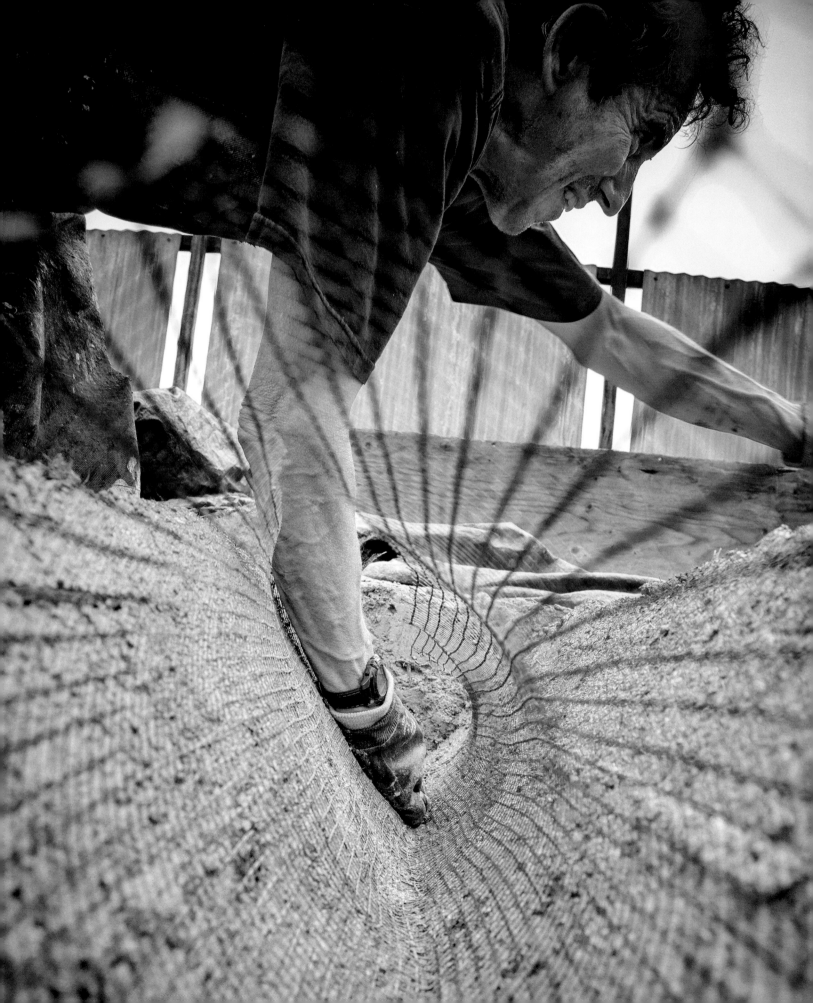

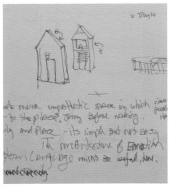

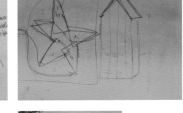

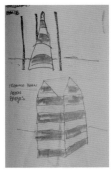

A series of artist notebooks created over the years by Thomas Sayre reveals that the Southern tobacco barn—as seen in the *Flue* earthcasting in Kinston, North Carolina, below—is a recurring theme and one that was on the artist's mind in graduate school in the 1970s (top right), as a new business owner in the mid-1980s (right), and again in the mid-to late-1990s (above). Kinston's sculpture became something of a precursor to the work in *White Gold*.

INTRODUCTION

by Gab Smith, Executive Director, CAM Raleigh

CAM Raleigh's mission is to provide the platform for enriching our community and empowering creativity through contemporary art and design. Our ever-changing educational and cultural experiences ignite ideas and connect people to what is now and what is next. More simply: CAM incubates creativity!

White Gold is a project that has incubated powerful new work in and from Thomas Sayre, an artist most familiar to us through his large-scale public art. CAM has given him the time, space, and support to create work that connects us to and helps us reflect on the landscape and the past with a physicality that is visceral. *White Gold* is alive and it moves us.

This catalogue celebrates Thomas as a painter and as a sculptor. The spirit of his work is fiercely described by filmmaker David Burris, arts writer Deidre S. Greben, poet David Dominguez, and playwright Howard Craft. The catalogue was gorgeously designed by Barbara Wiedemann and photographed by Art Howard.

White Gold was realized under the incredible leadership of board chair Charman Driver and continues the vision of Chairs Emeri-

tus Frank Thompson and Carson Brice. Bringing Thomas Sayre's work to the museum happened because of the constancy of CAM's visionary Contemporary Art Foundation and the unstoppable Betty Eichenberger Adams Society. Our City, our State, our board, our staff, our community partners, our friends, and our families give us the support and love to make us fearless. With infinite gratitude, *White Gold* is dedicated to everyone who believes in CAM.

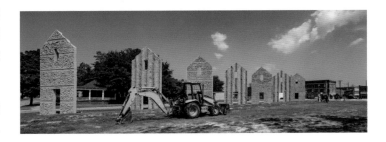

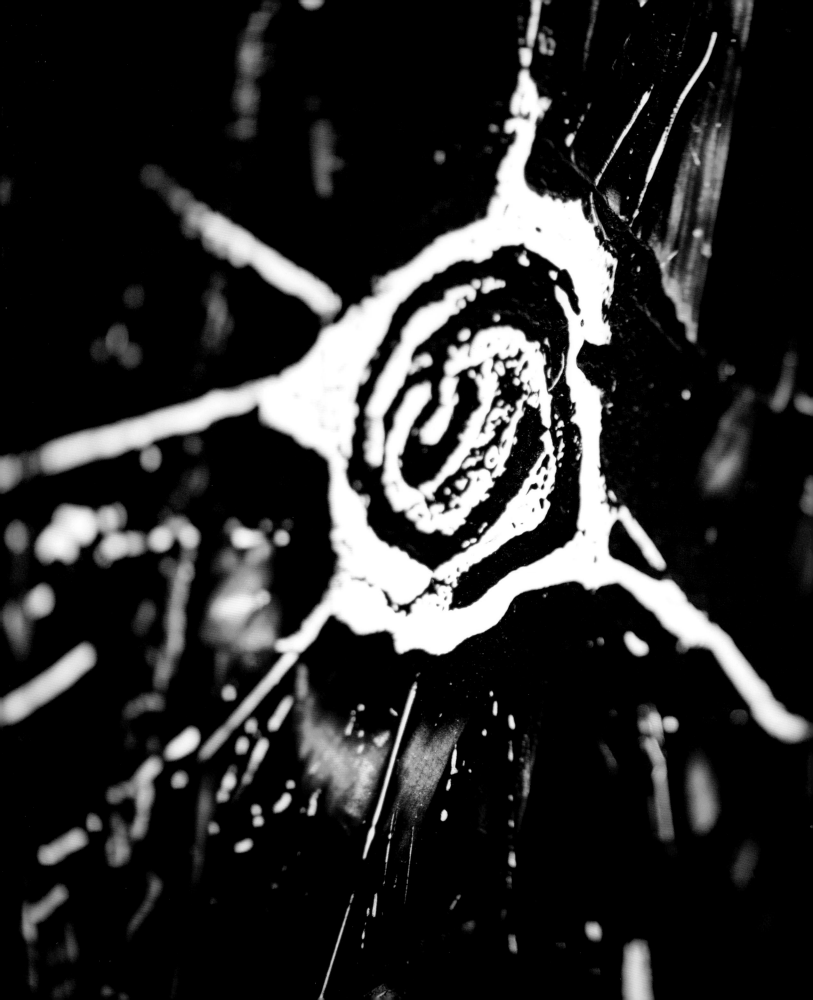

THOMAS SAYRE AT CAM RALEIGH

by Deidre S. Greben

That Thomas Sayre found his most recent subject in the cotton fields stretching across the plains between Raleigh and the North Carolina coast is unsurprising. The plant's tactility, the clusters of soft white fiber burst from dark thorny bolls, and its connection to the region also describe the 65-year-old artist's signature earthcasting sculptures, which integrate the local soil and are derived from molds formed by excavating large holes in the ground. But while Sayre literally uses the earth to produce his concrete casts, the wall pieces he created for *White Gold* reveal the power of the land to shape people.

Sayre's articulation of the long stems and stark white blossoms read not unlike passages in a Faulkner novel, perceiving the South's injustices while also venerating it. There is a bold yet ghostly quality to the hardened splotches of industrial paint that dot the wood panels, like musical notes that deliver a tone at once immediate and haunting. As in the Mississippi-born writer's stories, history asserts its presence in these images, becoming itself another element of the narrative. But here the artist possesses the distinctive perspective of an outsider within. Arriving in 1973 from the nation's capital to attend the University of North Carolina on scholarship, Sayre is an observer who has gradually become part of the local landscape.

Sayre grew up the son of the dean of Washington's National Cathedral, in a house steps away from the majestic, then-unfinished Gothic-style structure and its teams of clergy, artisans, and laborers. There he saw at an early age how three-dimensional space could stir emotion and convey meaning, how objects and images could be as potent as words. He also learned to build—and build on a large scale. An artist who claims minimal facility as a draftsman, Sayre constructs his visions, accumulating effects produced by a litany of invented processes that rely more on backhoes, shovels, and welding machines than on the conventional chisel or brush. His works are as much fabrications as they are renderings.

To create the sequence of panels comprising *Thicket*, Sayre began where, over the past two decades, he has become most comfortable—with North Carolina's indigenous red clay soil. Here, he rubbed the dirt into the sanded, pre-laminated white Masonite boards, as if to reassert the work's connection to the place it describes. To form the sprawling tangle of cotton plant stalks, he then used sticks and nozzled bottles to fling and squirt streams of clear acrylic floor finish across the mud-stained wood surface, lining up several panels on the floor at a time so as to not interrupt his arcs of movement. To be sure, the spontaneously streaked, splashed,

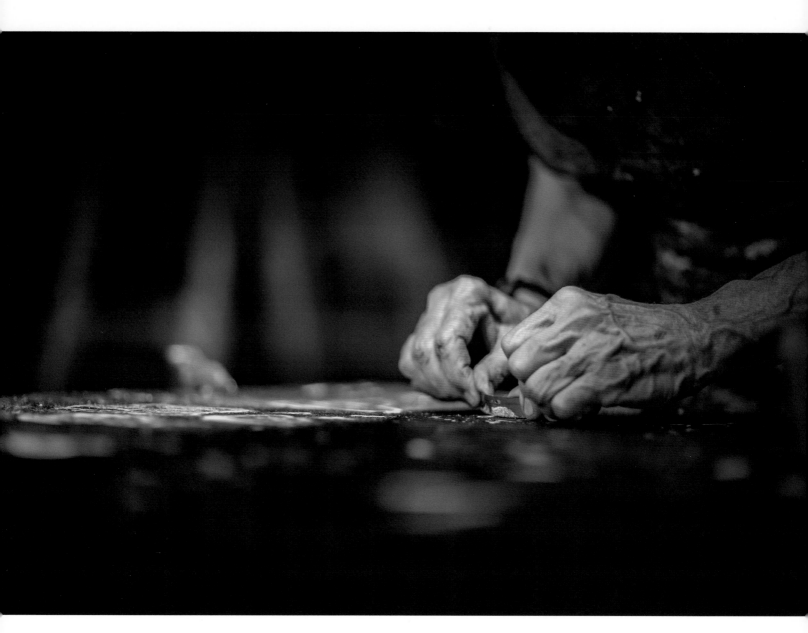

and dribbled markings invoke Jackson Pollock's gestural compositions. Like the New York School painter, Sayre turns our attention to the physical act of painting. But while Pollock's improvisational paint-flinging is non-representational, Sayre's draws on the physical action of portraying the cotton to evoke the labor that has been exploited in harvesting it.

Physical force is integral to his formation of the plants' downy clumps as well. After squirting puddles of bright white stain-blocker paint onto the wood panels, he then proceeded to repeatedly whack the blobs with flat sticks to create recesses in their gleaming surfaces. Using massive putty knives he fashioned from spring steel and aluminum, Sayre applied and then laboriously scraped off layers of black tar to imbue the blossoms and their willowy stalks with further definition. The successive veils of sepia-toned tar residue give Sayre's composition pictorial depth and a seductive yet discomfiting beauty.

Sayre's rich and complicated surfaces most often evolve through happenstance. The making of his 2007 *Tree Paintings* series, for instance, resulted from the discovery of some burn marks on the floor beneath the welding table in his studio. The various nicks and craters left by the pellets of liquid metal on the wood planks suddenly suggested to Sayre the scarred papery bark of the birch tree. After vertically positioning two steel rebars inches apart on a white laminated fiberboard canvas, he picked up his electric welder and

watched the beads of molten metal skitter excitedly over the surface between them, burning traces of their random paths into the board. The pockmarked, pigmented bands against the stark white ground capture the striking visual essence of a grove of birches he had encountered against a snowy Aspen slope months before. It was not the first time Sayre used unconventional methods to produce painterly effects. For earlier two-dimensional series, he applied soot using an acetylene welding torch, embedded glass in concrete, and aimed firearms at metal sheets and wood boards.

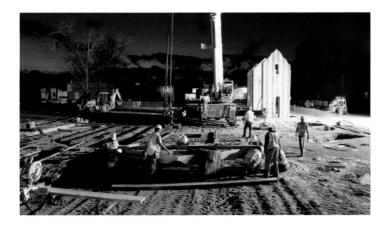

Interestingly, Sayre considers the process of making his wall works more challenging than producing the massive primordial casts he yanks from the earth. He has partners when making his sculptures, he explains—the crane operators, the concrete pourers, the rocks, silt, and grains of sand that push against and define their surfaces. To direct the earthcastings where he wants them to go, he must recognize and understand these forces and lean into them, a lesson, he says, he learned as a teen sailing off the coast of Martha's Vineyard. Without these influences affecting the outcome in his paintings, controlling and not controlling the forms and patterns that result, Sayre is forced to rely more heavily on himself.

Crane operators, concrete pourers, and other partners help to assemble *Flue* earthcastings in Kinston, North Carolina (above), photo courtesy Minnow Media. *Shimmer Wall* on the facade of the Raleigh Convention Center (top right) and *Curveball* at Nationals Park in Washington, DC (bottom right), photos courtesy Clearscapes.

Led by his penchant for collaboration, whether with nature's elements or individuals, Sayre cofounded the Raleigh-based multidisciplinary design firm Clearscapes with architect Steve Schuster in 1981. The two met while developing a playground for severely handicapped patients at a residential treatment facility and have worked side-by-side ever since, pushing against myriad forces—site features, budget parameters, city planning regulations—to realize a wide range of projects, from his *Shimmer Wall* on the facade of the Raleigh Convention Center to *Curveball*, a sequence of polished stainless-steel spheres adorning Washington, D.C.'s baseball stadium, Nationals Park. As a key member of the Clearscapes team, Sayre intervenes with and reflects the community around which his art is made. In this way, his practice relates to the large-scale outdoor works and fabric-wrapped buildings of the husband-and-wife artist team Christo and the late Jeanne-Claude, who also involved a cast of many to realize their installations. Similar to the duo's transitory creations, Sayre's earthcastings function as disturbances in the landscape, making us aware by mirroring and interrupting the view.

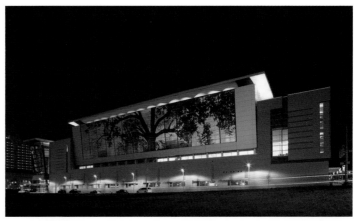

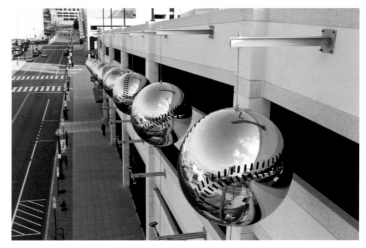

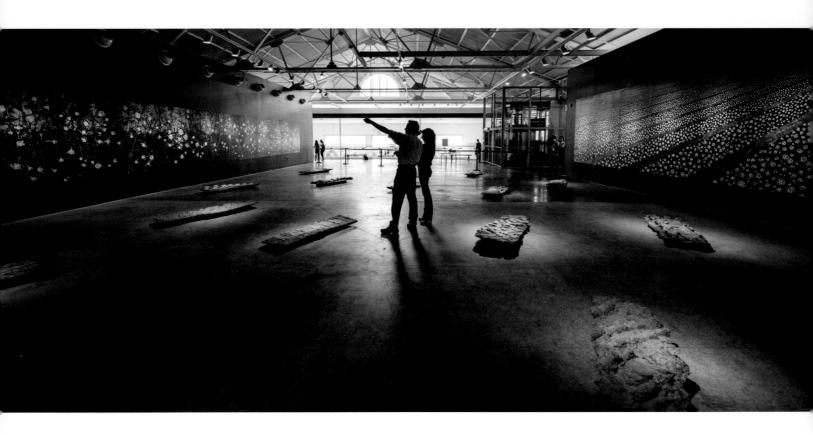

In effect, Sayre's *White Gold* installation does the same. Here, however, he does not physically insert his work, but the viewer, in the terrain. Looking at *Thicket*, museum-goers find themselves immersed in a row of cotton, eye level with the tall branches and dangling raw bolls. While the tar-striped panels that make up the *Barn* series seemingly offer a dramatically different perspective of the fields—through gaps between abstracted wood slat imagery—the paintings function similarly in terms of enveloping the observer. Like the bands in Barnett Newman's trademark "zip" paintings, Sayre's uneven horizontal ones do not divide the painted surface, but merge the space, reaching out to draw in the viewer standing in front of them.

The sweeping 40-foot panorama of the expanse of field portrayed in *Row* extends the view, as do the earthcasting floor sculptures comprising *Track*. While evoking the narrow dirt paths between planted rows, the redundancy of the syncopated mounds echoes the grueling repetition slaves were forced to endure handpicking the mature fiber from its spiky encasements. As with Sayre's other earthcastings, the character of the local soil seeps in and is reflected in the sculptures' encrusted veneer. But here he has taken further pains to scar their surfaces, scraping off the top soil and pressing track-hoe treads, backhoe buckets and teeth into the earth, summoning the physical and emotional wounds inflicted by the overseer's whip. "Sure, it might etch deep gashes in the skin of its victim, make them 'tremble' or 'dance,' as enslavers said, but it did not disable them," writes Edward E. Baptist of the leather tool in *The Half Has Never Been Told: Slavery and the Making of American Capitalism*. "In the context of the pushing system, the whip was as important to making cotton grow as sunshine and rain."

With *White Gold*, Sayre continues to mine mankind's delicate relationship with the land. Viewers find themselves uneasy in this familiar garden of splendor, at once seduced by the cotton's lush glow and the depths of its darkness.■

(above) Thomas Sayre with CAM
Raleigh Executive Director Gab Smith
during the installation of *White Gold*.

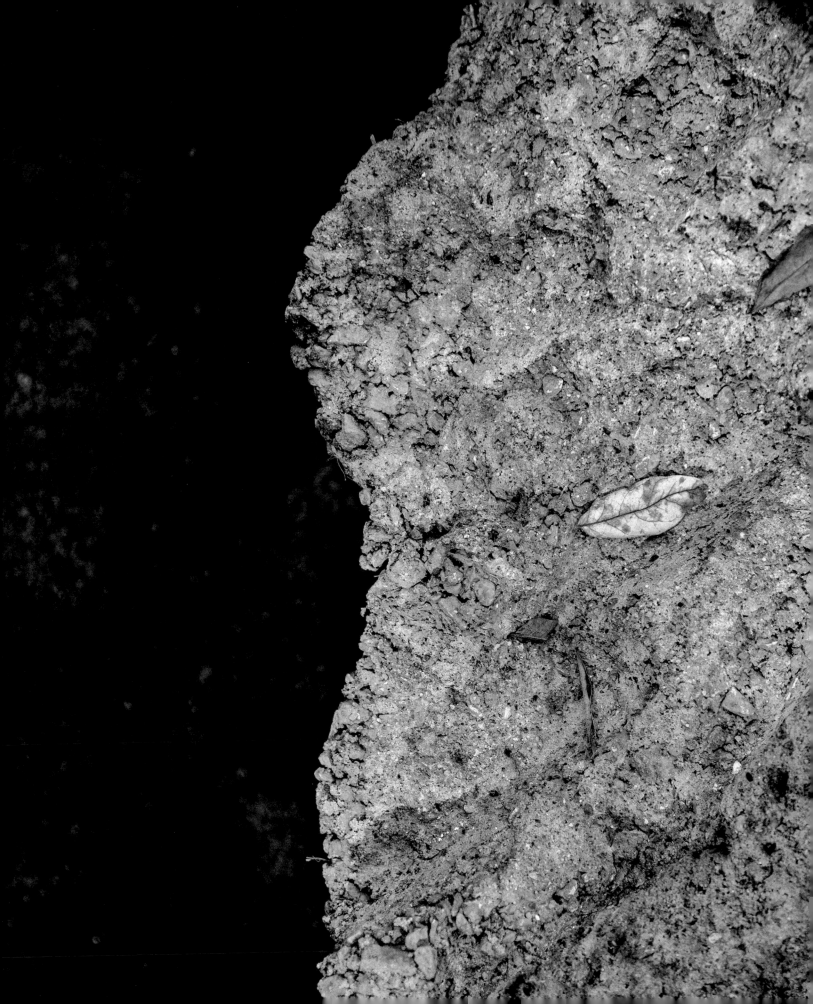

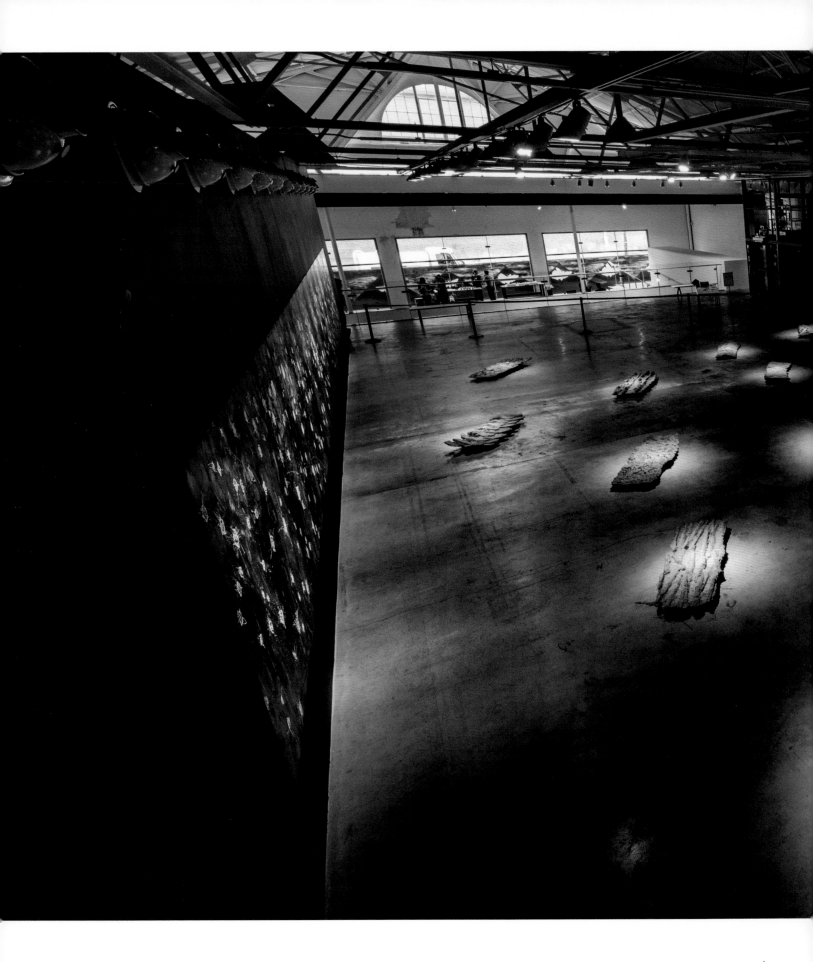

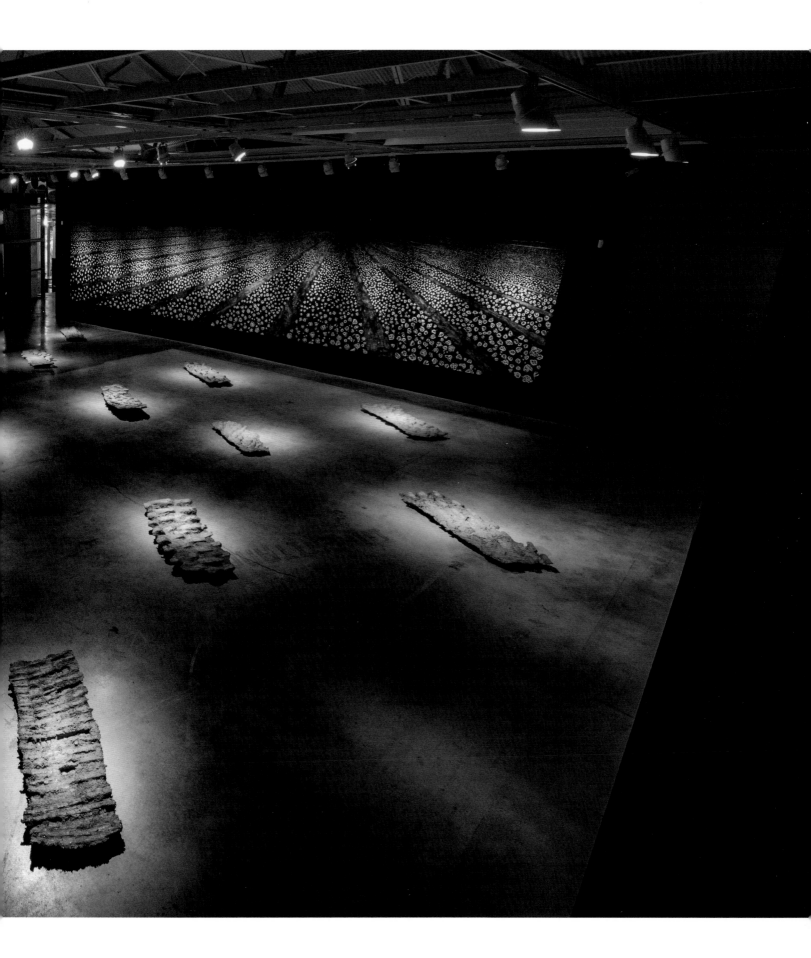

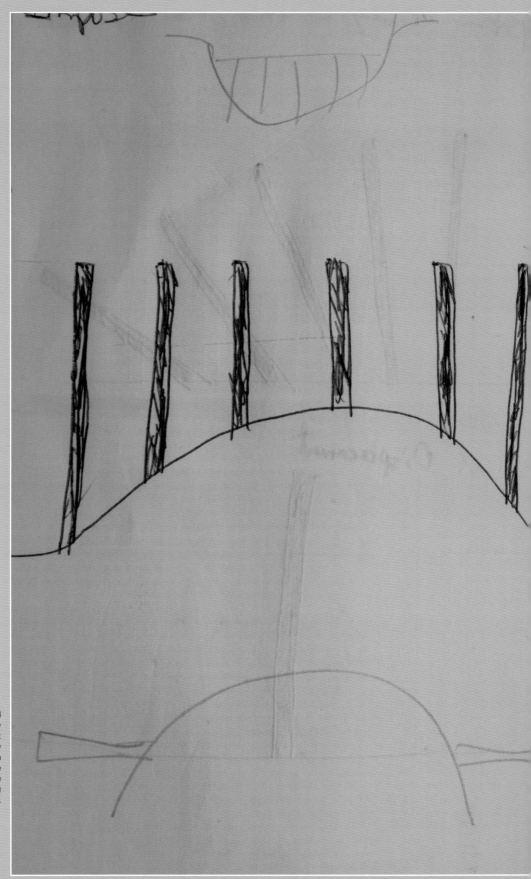

Sketches from an early graduate school notebook, circa 1970s at Cranbrook Academy of Art in Bloomfield Hills, Michigan, reflect the early moments of a lifelong journey exploring the meaning of art and, in particular, sculpture in the landscape. Here gestural exercises elegantly capture the notion of imposing *on* the landscape (left) versus conforming *to* the landscape (right).

Contour

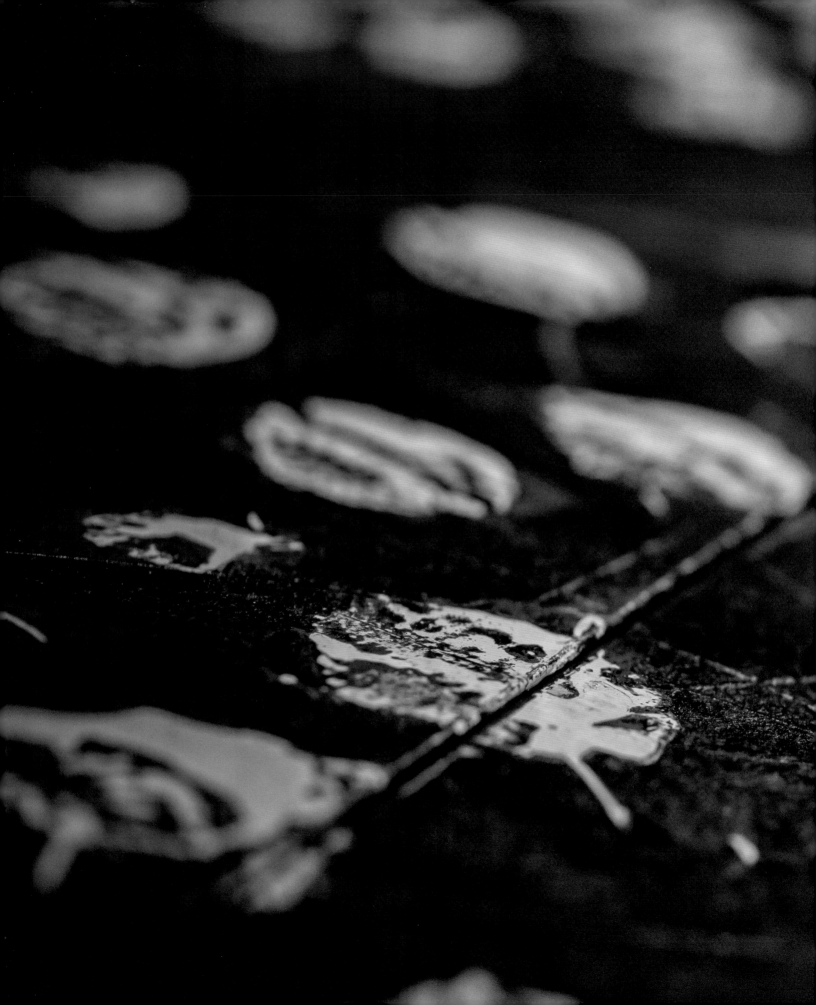

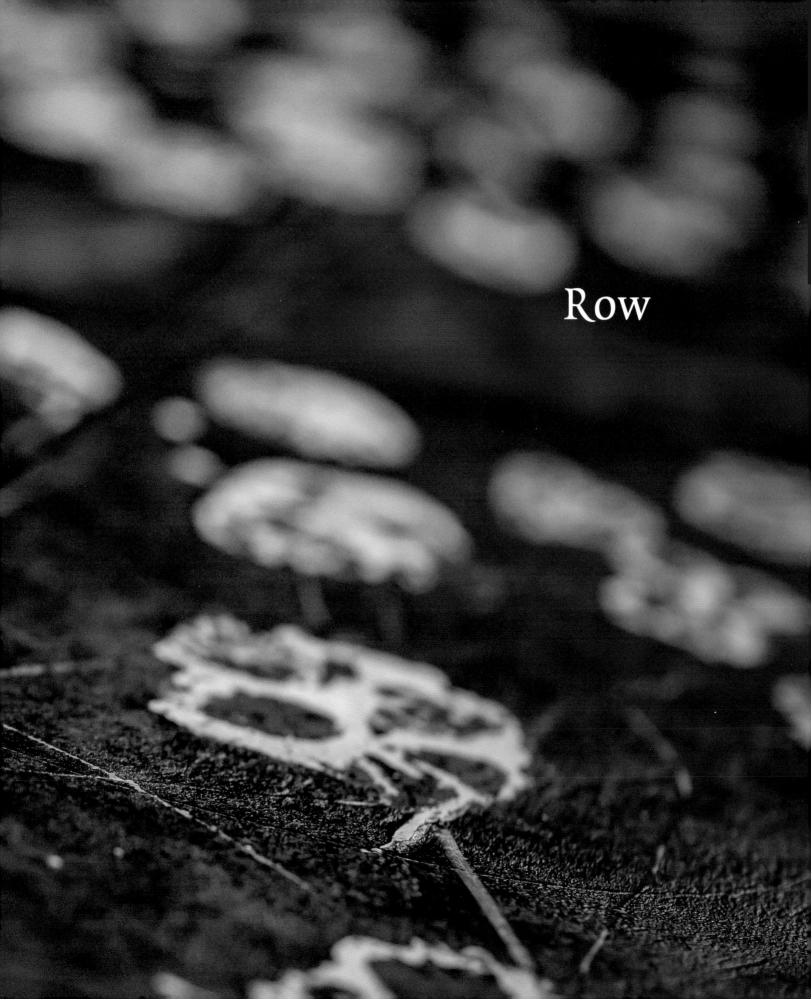

Row

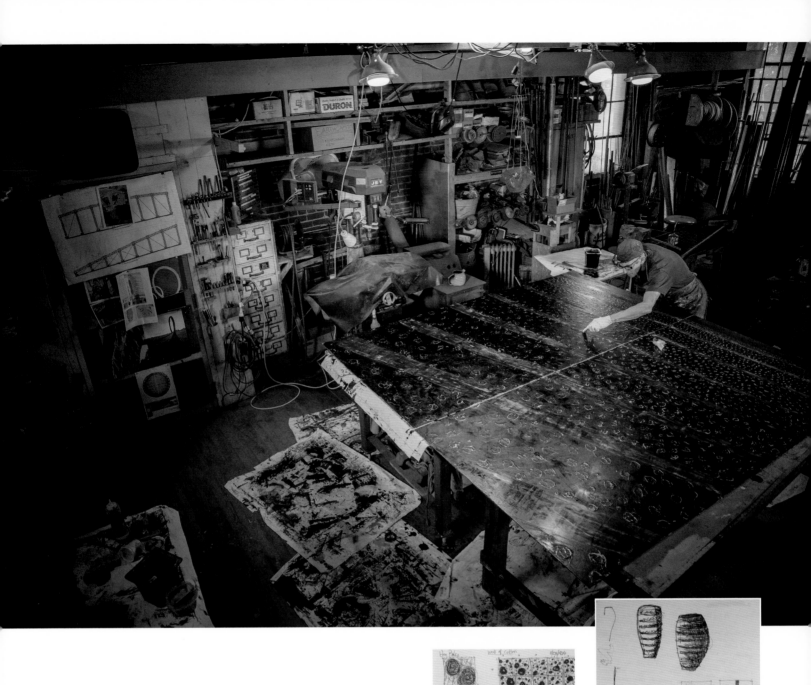

Sketches from the mid-1990s (far right) reveal Sayre's fascination with the visual patterns inherent in the farm fields of eastern North Carolina; later sketches are more directly linked to *White Gold* (right).

VOICES

by David Dominguez

 Last night, I wandered the backyard with my pitbull
sniffing after the opossum as it darted up the fence post.
I placed the sprinkler on a patch of crabgrass,
straightened the kinked hose, and opened the valve
because I needed to hear drops of water
tap the leaves spread against the sky.
 Hours before, I'd finished reading a book.
Voices turned, fell, and sang brightly as stars,
and since the voices refused to stop, I picked up my notebook
and tried to fill the space burning my eyes,
crossing out page after page with my Mont Blanc,
nothing but adjectives and weary phrasing,
not one image I hoped would rise at the end of a line,
so I left it on the coffee table and walked outside
where a train horn rattled the air.
 In the garden, I heard more voices as my shoulder
brushed the umbrella tree dusted with mildew and spider web,
Amigo, take some time, sit, meditate, and write...
I wanted to collect the week's morning hours
when the house hums in the silence of the full moon,
when the first doves moan from the phone lines,

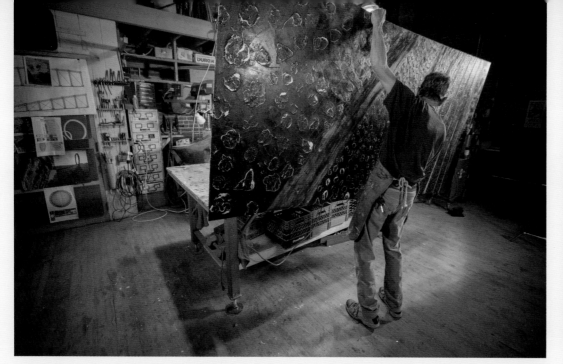
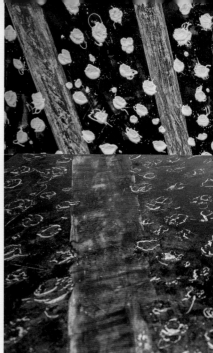

and the kitchen knows nothing but coffee and pumpkin empanadas.
But struggle abounds everywhere, every day—
ivy splitting the fence slats and choking the honeysuckle,
black wasps hunting crickets and dragging them
into their subterranean nests beneath the orange tree...
weeks ago, men ground a pine stump down to nothing
and used a reciprocating saw to remove the roots,
saturating the backyard with the scent of sap.
But now, the crickets rose and sang against the house,
and the image of my notebook, almost as blank as
the space between the stars, lingered in my mind,
ink bleeding through each page, not one image that shined
among smears left in the margins as the piston ran dry.
 I thought then about my friend Thomas Sayre,
how we clinked bottles of IPA over popcorn this summer
as we leaned against his kitchen counter, and he said,
There has to be that itch, then craft, then it must be about something,
as he raised his arms about his head and described
the night he drove past Raleigh, pulled to the roadside,
and followed the breeze and the smell of clay
into the cotton fields as they quivered and rustled
among shadow, light, and the hum of insects,
nothing else but stalks, claws, and bolls climbing a wall of constellations

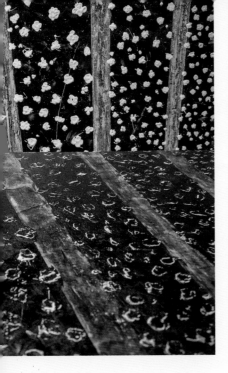

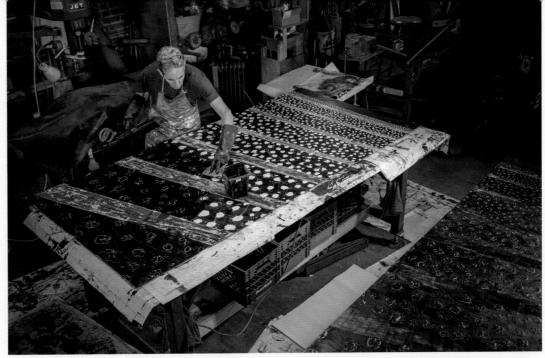

and how he, too, heard voices, voices that rose

from the furrows as dirt clods crunched beneath his boots.

Wailing? I asked as we opened two more bottles.

Yes, he said, staring out the window...*Wailing, that's the word.*

And the next day, in his studio—an abandoned plumbing warehouse—

Thomas showed me three mounted wall pieces.

One, 8′ × 40′, contained thousands of bolls that flooded the sky like stars.

I studied the work, asked, *How do you do it?*

I smear red clay over white Masonite with my hands,

use a stick or a brush to drip, dribble, and fling

varnish onto the board to make the stems,

then apply KILZ and shape the bolls, and after they dry,

smear Mule-Hide Roofing Tar over everything.

I stared at the piece, inhaled the smell of tar, and said,

But the bolls, there are thousands of them—how did you do that?

The stalks are luminescent and shine through,

so I scrape at the tar with a knife and reveal the blossoms one by one...

 And recalling all this, I left the garden,

returned to my desk and stacks of books, fountain pens,

ink jars, and paper, pushed open the window,

and—the house silent except for the opossum in the orange tree—

scraped at the pages until the first image

wailed and shined against the moonlit horizon.

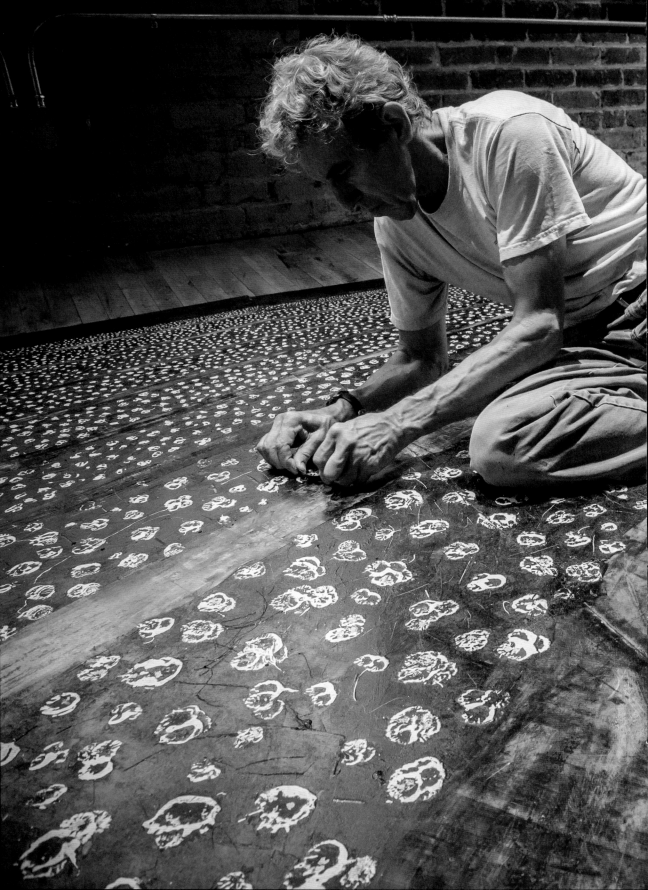

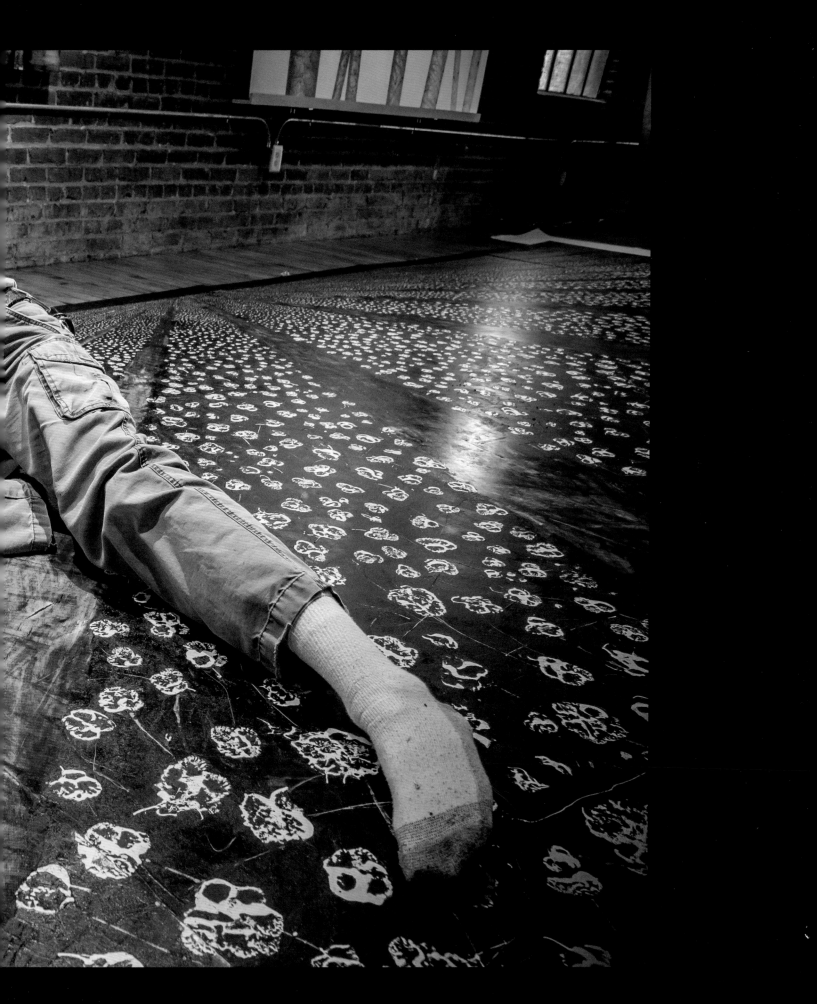

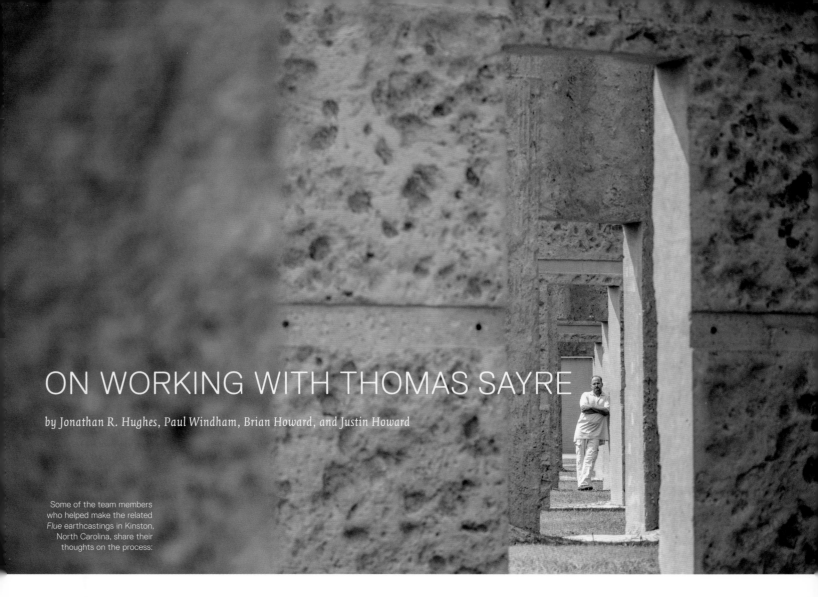

ON WORKING WITH THOMAS SAYRE

by Jonathan R. Hughes, Paul Windham, Brian Howard, and Justin Howard

Some of the team members who helped make the related *Flue* earthcastings in Kinston, North Carolina, share their thoughts on the process:

"When I was nine years old, the farmer would come by our house. We'd get in the back of his pickup truck, get taken out to a tobacco field somewhere, and crop tobacco leaves all day long....Those rows never ended."

"I remember as a child getting to the end of the tobacco row. And the Harvester would turn to go back down again, this mile-long path, and the tears would roll down my cheeks."

"To come back twenty-five, thirty years later, to build a piece of art that pays homage to where we came from...is pretty incredible."

"For this project, there was an end in sight. For six months, we were just messing around in mud. Everybody in town was saying 'What the hell are they doing?'...Some days there were 60 people out here, tying rebar and moving earth. Thomas would come in from Raleigh, we'd have a pow-wow."

"So far, this is the most unique thing we've done. I hope it's not the last. All of us have talked about this. We would love for Thomas to call us and say 'look, I've got a project and I need guys like you. We'd *take off* and do something else with him. Another project would be like icing on the cake."

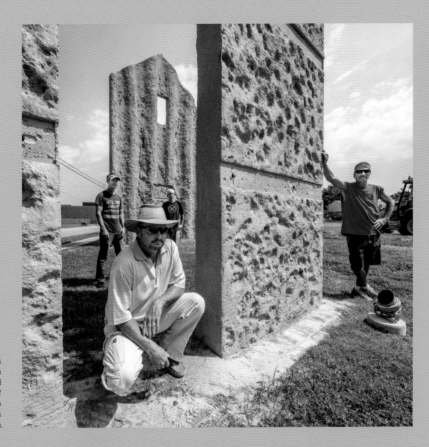

Jonathan R. Hughes (foreground) with Brian and Justin Howard and Paul Windham (right), all of whom worked with Sayre to build the *Flue* earthcastings in Kinston, North Carolina.

"We've worked together for years. We get a system going so everybody isn't all up and running into each other."

"For some reason, he thought we could do it. And we all thought we could do it."

"All of our names are on the first earthcasting down there. They're covered up, but we know they're there."

"Thomas is very organized. Most artists I know—I've gotta be honest with you—they're not that organized. He's extremely precise…. He'd say 'This is what we're gonna do. This is how we're gonna do it. And if you trust me, we'll get it done.'"

"He was always allowing us to get our hands dirty, so to speak, and to become part of the project. Not just go to work. So we all felt like we owned it just as much as Thomas."

"It's amazing how coordinated we were on this job. Everyone had their spot, their thing to do. He'd direct it, and we got better and better with each one."

"He's competent. Competent, and confident. The way he does something, you don't see him second guessing himself or changing his plan up when it's not necessary….It was inspiring, really. "

"Everybody got up every morning knowing we were going to do something great. And to be a part of something great is every person's dream, I think. At the end of your life, you want to be a part of something great."

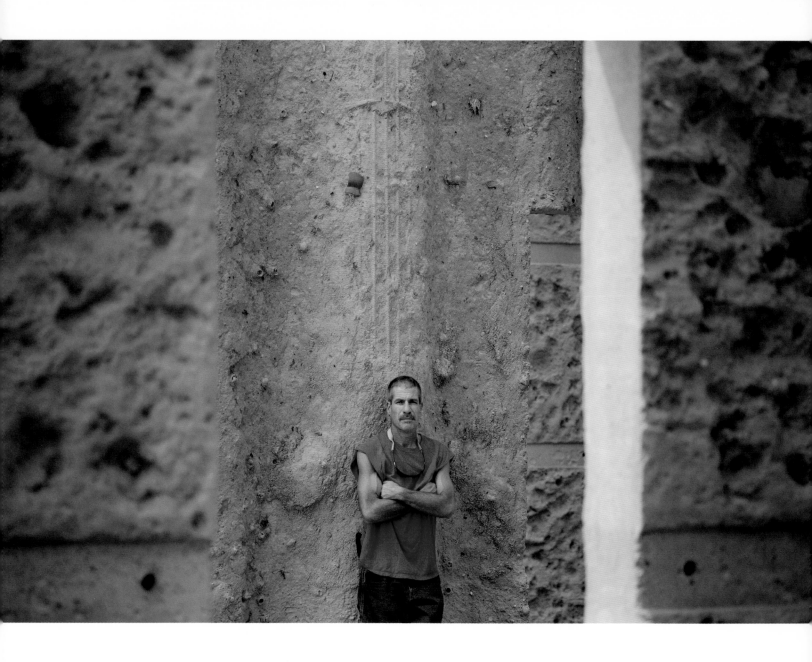

"It's a legacy. You're leaving something. That's really what you want. It's not about money. It's not about fame. It's really about what are you leaving the generation behind you to enjoy."

"It's amazing what you can do when you get a bunch of people together. It's so much more powerful than what one person can do."

"I tell you what else, Thomas inspired us to treat everything we do like art. Everything we do got better since this project. Thomas has made us all more creative."

"Thomas doesn't want the credit. He wants the community to get the credit. I think Stephen [Hill] is the same way. He's shaping the culture of this town."

"It's like taking a step back and taking a different look at life. I'm not here by myself. It creates something we're sharing with everyone around us."

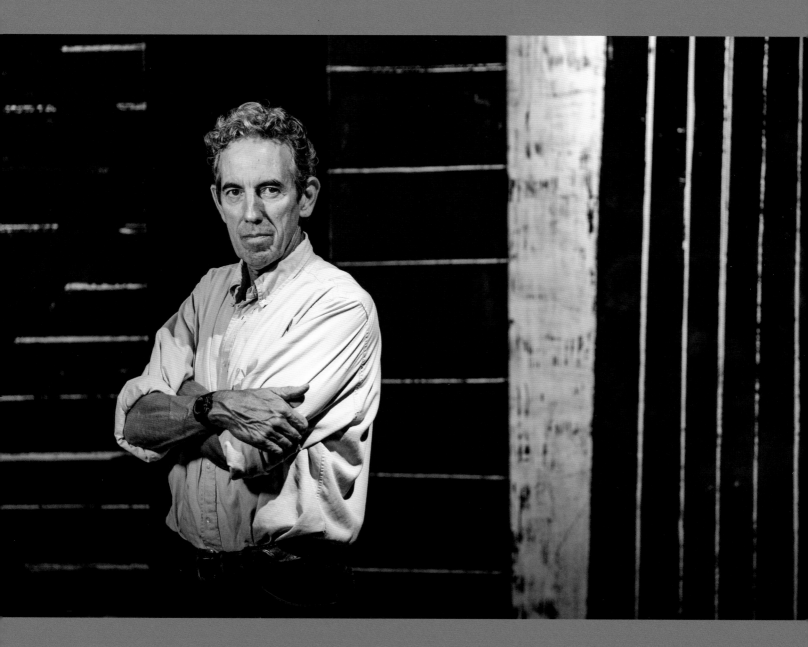

"My work over the years has afforded me the opportunity to work with both small and large teams of people. In partnership, we have made some amazing things happen—things that I could never have produced alone. Whenever I pull up a large earthcasting out of the ground, I am struck by a feeling of gratitude at being able to do work much larger than what I can do by myself. It reminds me of what I saw happening all around me growing up in the shadow of Washington Cathedral. There I saw craftsmen, laborers, artists, and engineers all working together on something much greater than any of them alone, to create an inspirational place worthy of being called a cathedral. Now—with this *White Gold* exhibition—CAM Raleigh has given me the opportunity to look within myself apart from the larger public projects. My time alone in the studio has been a gift involving testing and experimenting how to capture my love for the fields of the South and for the hard stories embedded in our earth. This exhibition has inspired a lot of searching. I've looked back through my notebooks to find decades of references about the way light finds its way through chinks in an old barn wall, or how to express the feeling of otherworldliness induced by row upon row of cotton in a long, flat field. I've searched for materials and techniques to capture the stark whiteness of a cotton boll in the sharp thickets of the field. I've wrestled with the hard history embedded in the red clay and what I could add to this very complex and potent story. In the end, I'm grateful for the time to work through this large idea and intrigued by the challenge of working mostly on the wall, alone in my studio."—THOMAS SAYRE

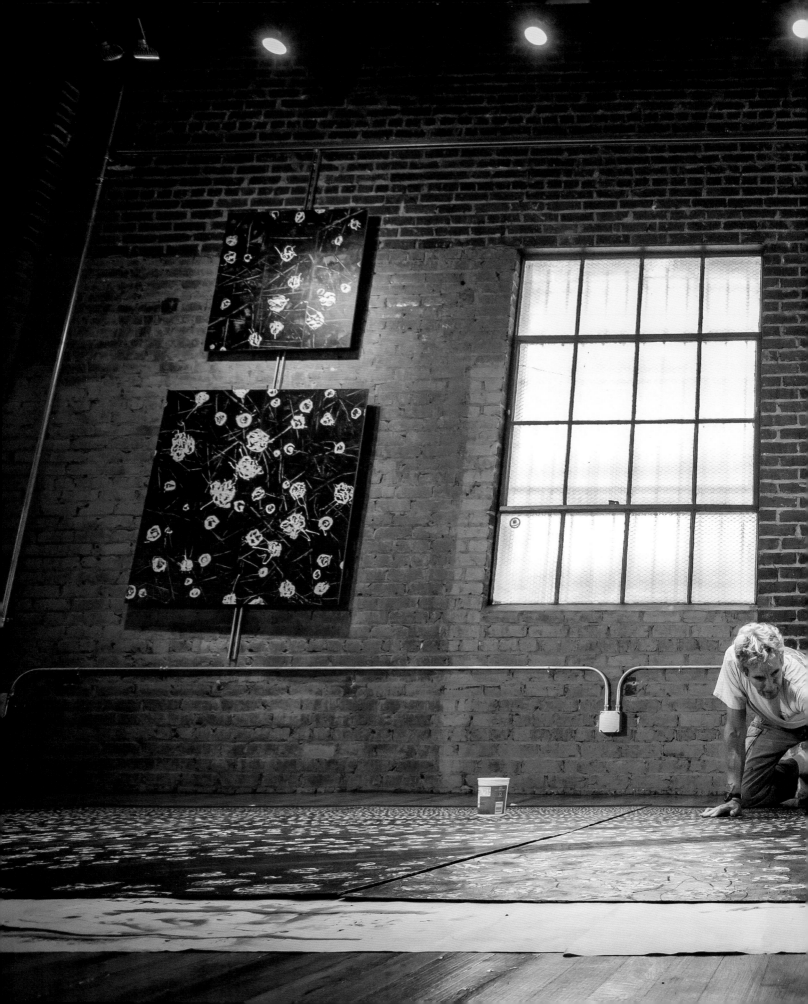

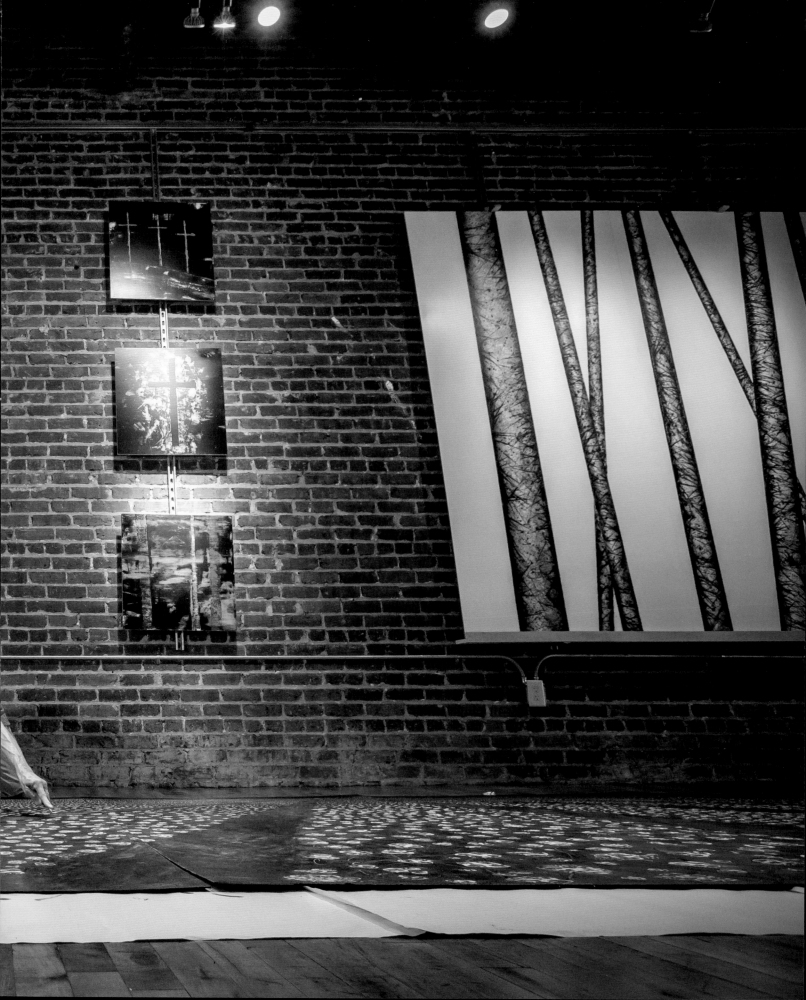

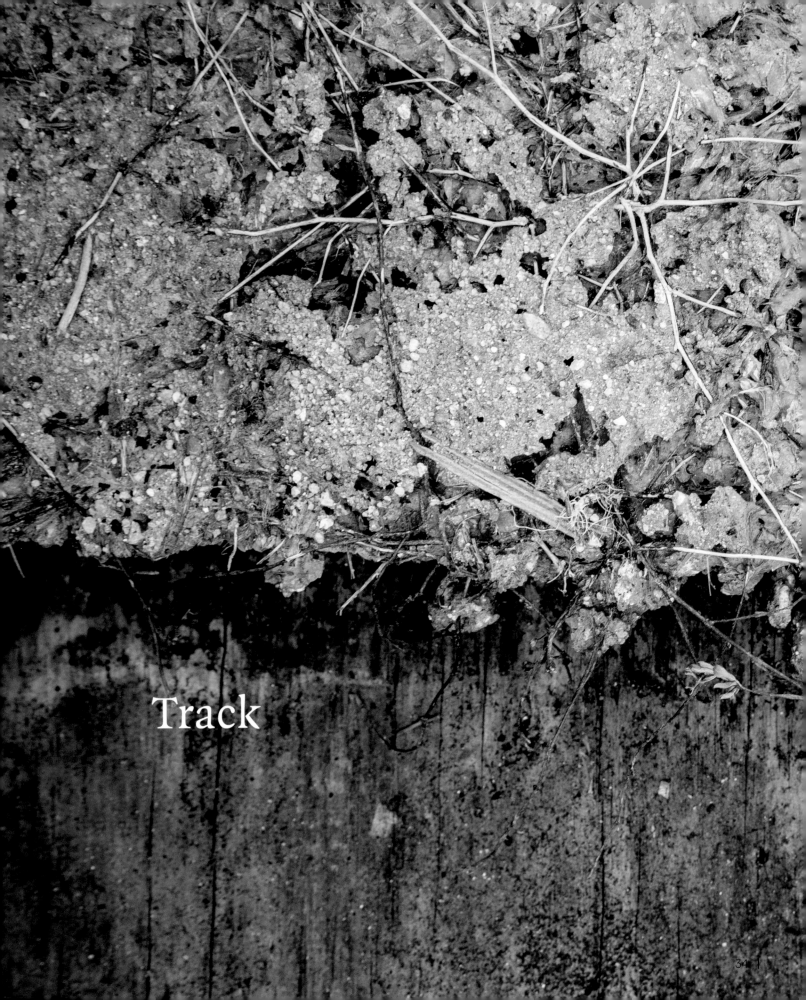

Track

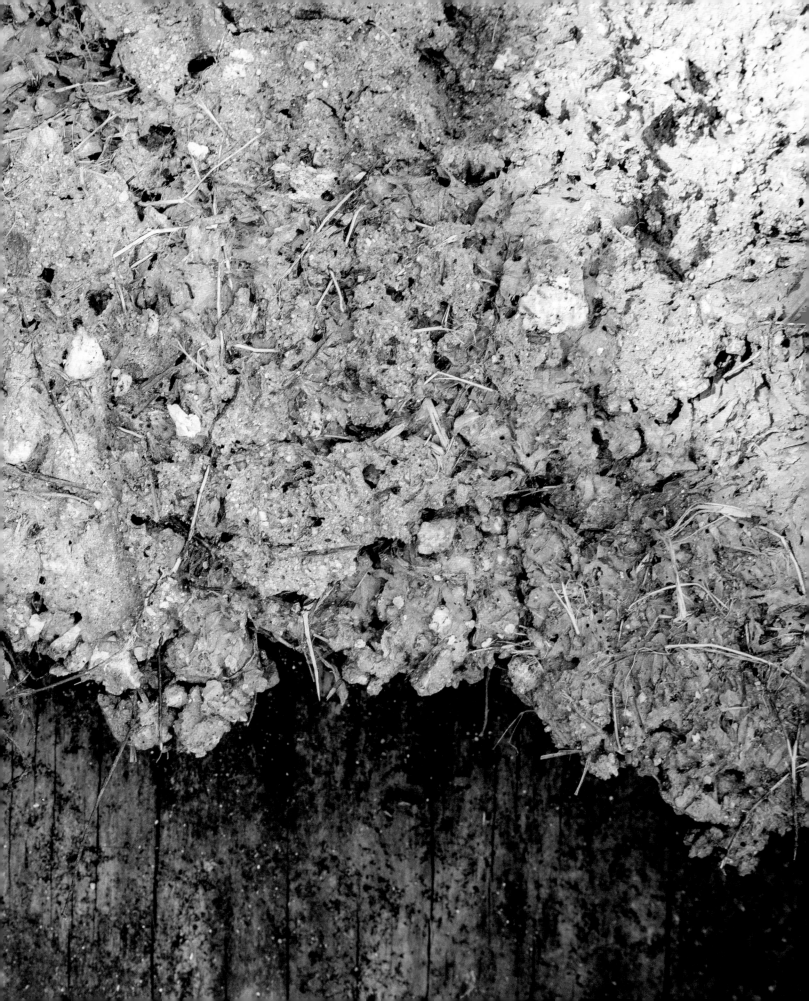

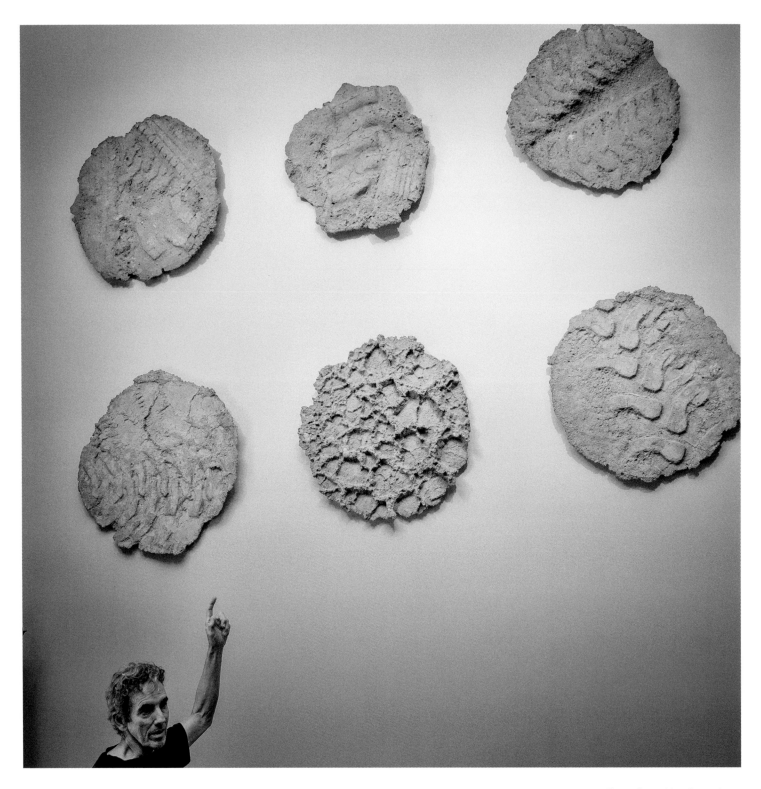

Thomas Sayre with early experiments with the materials and processes that lead to the creation of the *Track* series within the *White Gold* installation.

COTTON

by Howard L. Craft

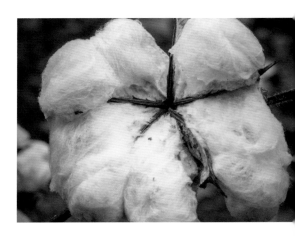

It could be skulls
Grimacing from ground
In hotter than hell heat
Packed in rows
Like bodies.
It could be dreams,
Clouds lifting from soil,
White nappy Afros
Building Britain,
Making America matter more
Than tobacco or sugar cane
Or justice or freedom.
It could bring wealth
To the owner of its fields
Or barely enough to survive
For those who put it in sacks
To be weighed or through mills
To make, shirts, dresses, coats.
It could be beautiful landscapes,
A painting that lifts the spirit
With happy Negroes
In bright-colored head scarves,
Or punishment and suffering,
Bleeding hands bent backs,
Slave, tenant, or prison labor.
It could be called white gold
Or Black misery
Or both things at once,
Rising toward the sun
In a southern sunbaked field.

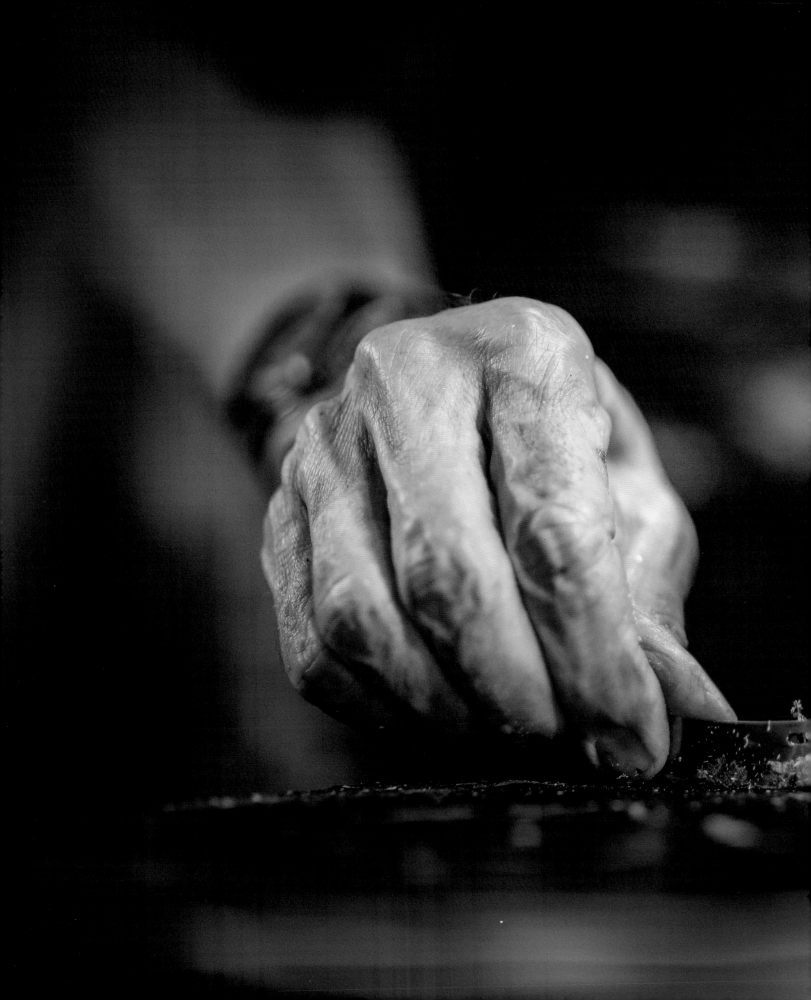

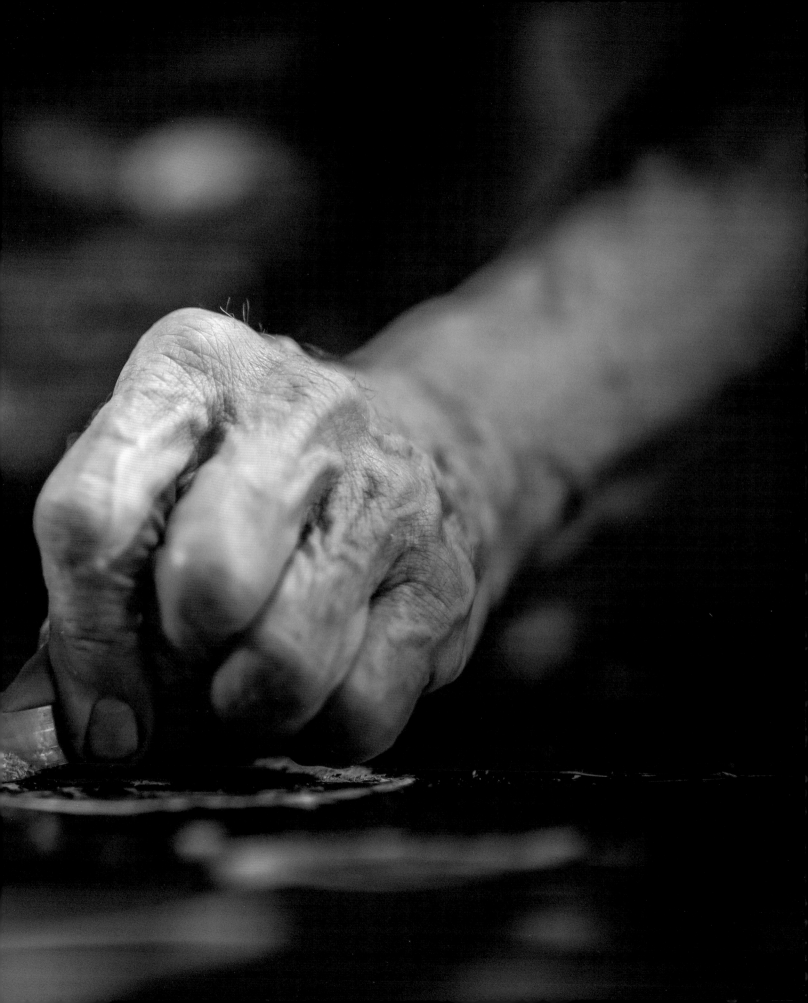

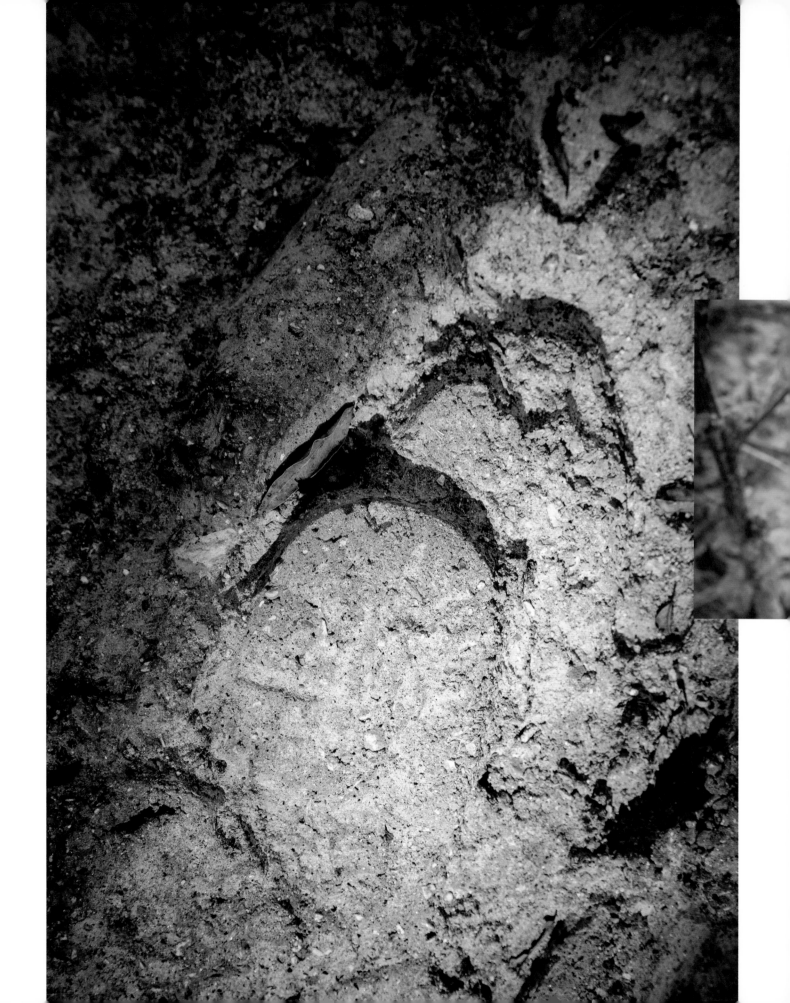

MI HISTORIA

by David Dominguez

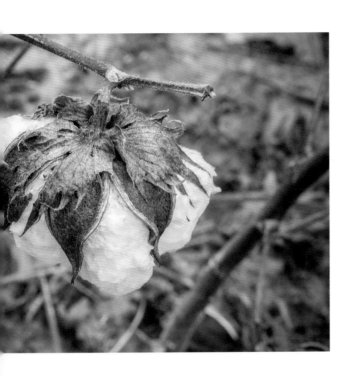

My red pickup choked on burnt oil
as I drove down Highway 99.
In wind-tattered garbage bags,
I had packed my whole life:
two pairs of jeans, a few T-shirts,
and a pair of work boots.
My truck needed work, and through
the blue smoke rising from under the hood,
I saw almond orchards, plums,
the raisins spread out on paper trays,
and acres of Mendota cotton my mother picked as a child.

My mother crawled through the furrows
and plucked cotton balls that filled
the burlap sack she dragged,
shoulder-slung, through dried-up bolls,
husks, weevils, dirt clods,
and dust that filled the air with thirst.
But when she grew tired,
she slept on her mother's burlap,
stuffed thick as a mattress,
and Grandma dragged her over the land
where time was told by the setting sun....

History cried out to me from the earth,
in the scream of starling flight,
and pounded at the hulls of seeds to be set free.
History licked the asphalt with rubber,
sighed in the windows of abandoned barns,
slumped in the wind-blasted palms,
groaned in the heat, and whispered its soft curses.
I wanted my own history—not the earth's,
nor the history of blood, nor of memory,
and not the job found for me at Galdini Sausage.
I sought my own—a new bruise to throb hard
as the asphalt that pounded the chassis of my truck.

"Why cotton? One answer is that it is a lens to view agriculture, in general, with cotton being a particularly charged version. I suppose it all began many years ago while in college. I attended one of the State's first fiddler's conventions in central North Carolina that spring, and I vividly remember venturing out into the nearby fields in the early morning hours. I walked out between the rows and felt compelled to drop to the ground, face up, looking at the stars, listening to the night sounds, and feeling the adjacent barns guarding the land. I imagined whose footsteps had come before me on the clay-filled soil and wanted to embrace the furrows, the dirt, and the plants that you could almost hear growing. It was a feeling of being surrounded and pulled down while my mind struggled with "big picture thoughts" of growth, decay, timelessness, and loss. *Row. Track. Barn. Thicket*. In part, these works came from that seminal experience. I hope the viewer will feel similarly enveloped by the breadth of our beautiful, rich, and haunted land." —THOMAS SAYRE

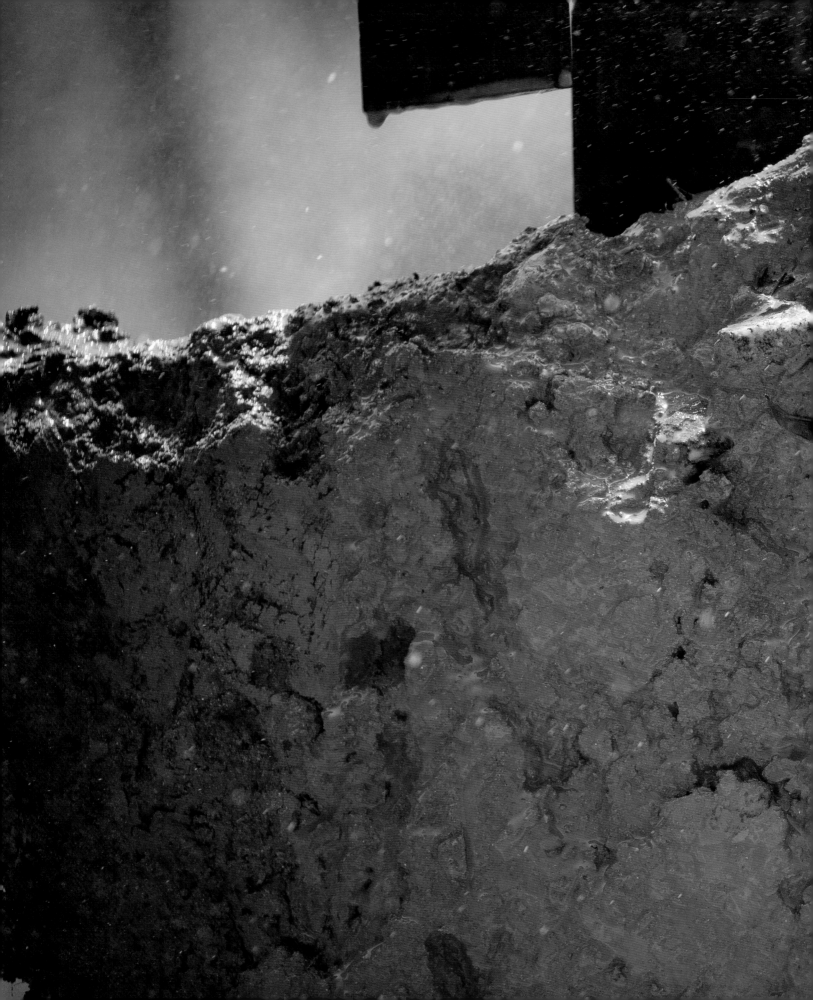

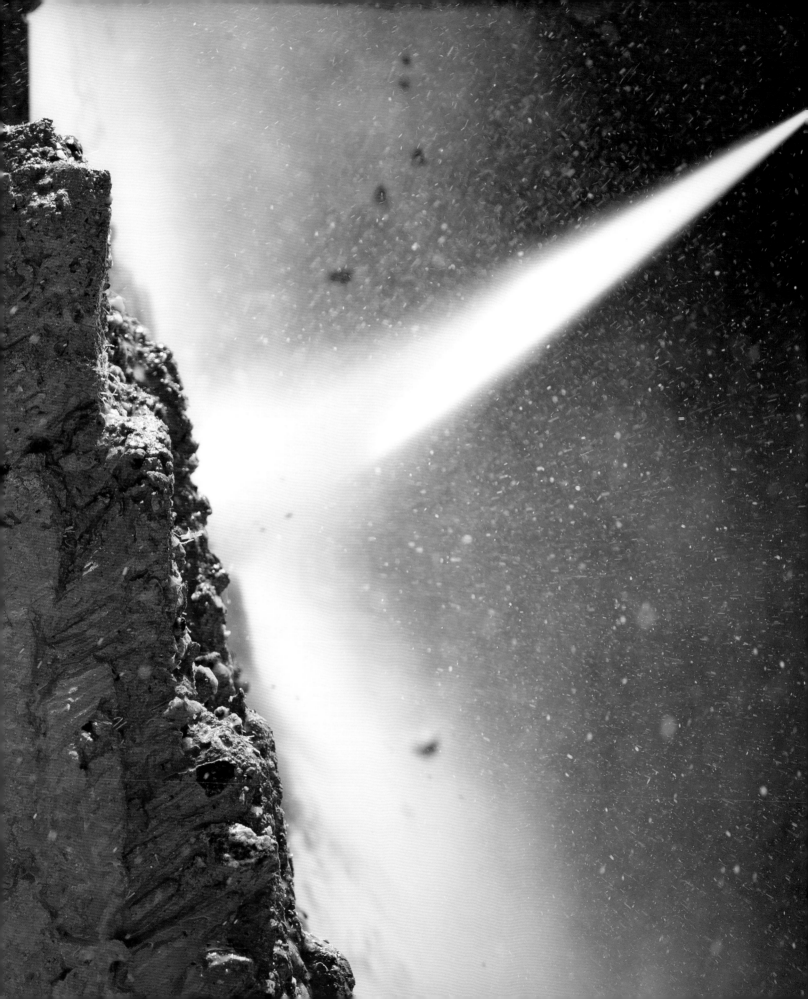

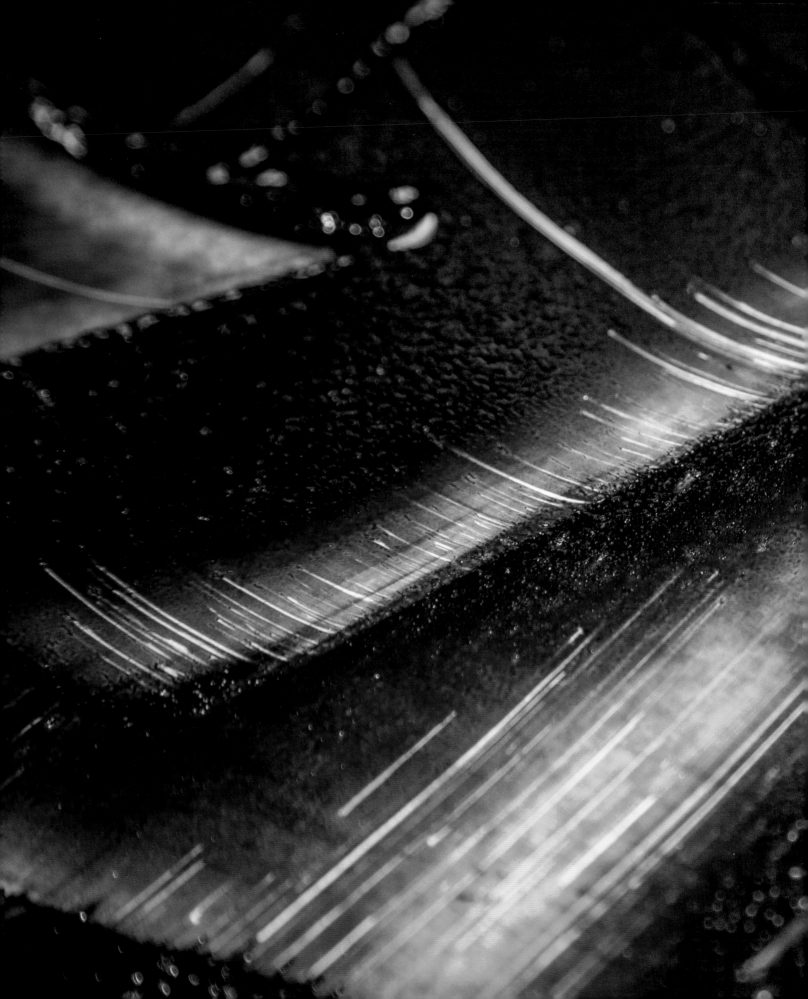

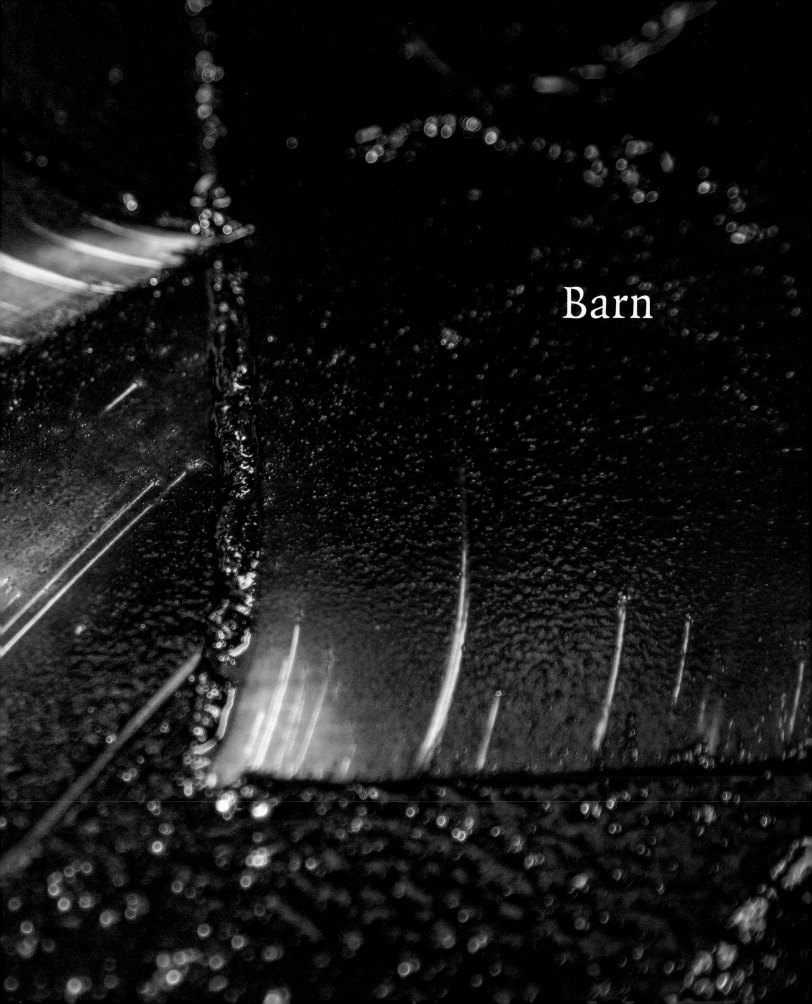

Barn

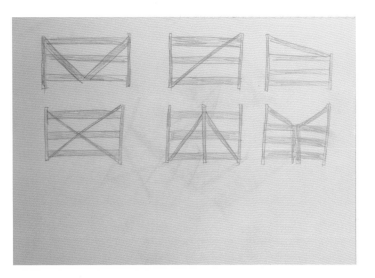

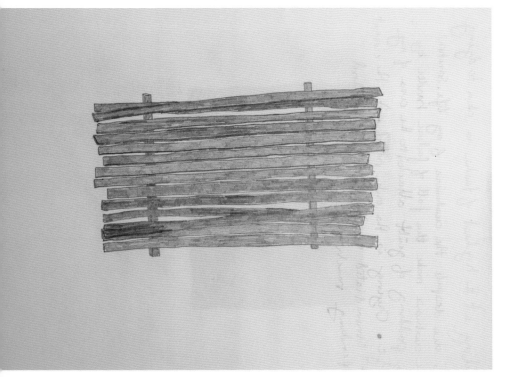

Early barn doors from Sayre's artist notebooks in graduate school at Cranbrook Academy of Art, circa 1974 and 1975.

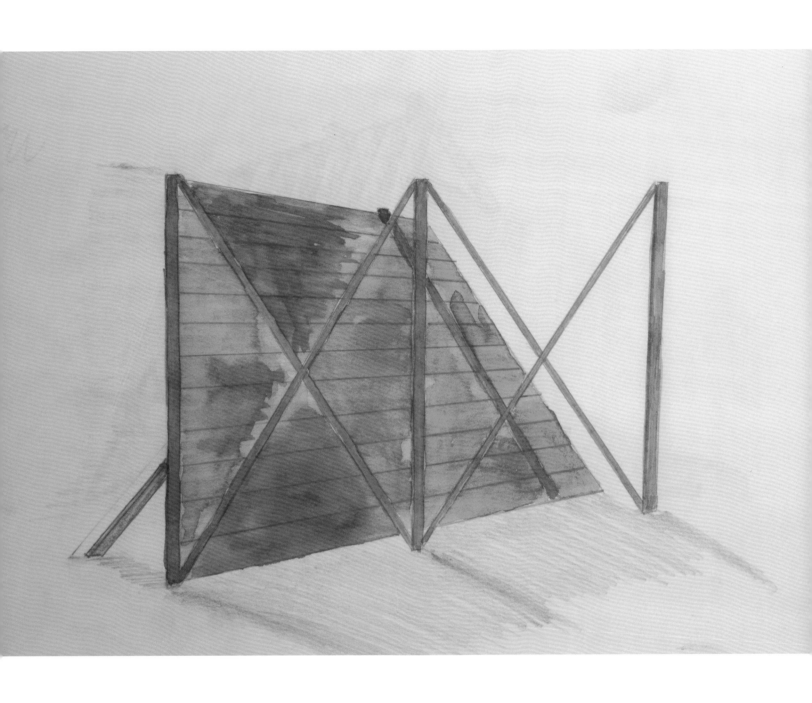

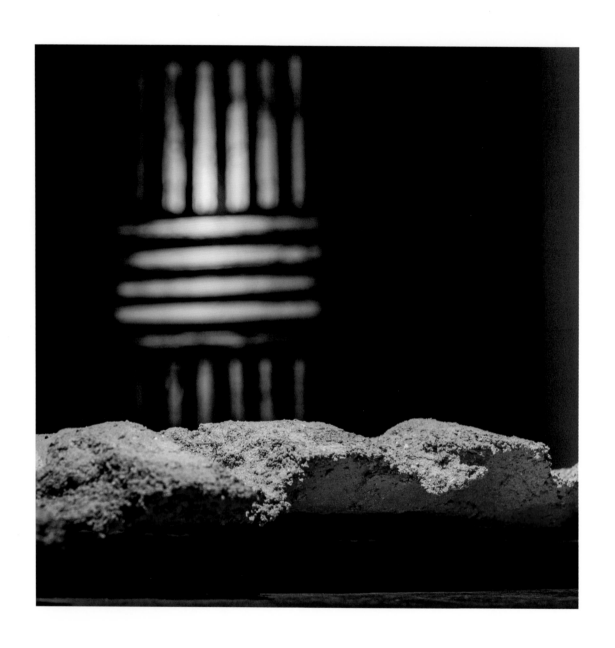

LAPSED TIME

by David Burris

Sometimes you wake up in the quilted, rainy, mid-morning light of a strange room. It takes you a minute to figure out where you are, but the lack of familiarity gives you a pleasant sense of displacement. And a welcome absence of responsibility. You've escaped. For a little while at least.

Sometimes you wake up with the sharp, parallel lines of the early morning sun scissoring the blanket of deep, deep slumber that can only fold over you in a familiar room. You've awakened in this room a thousand times. You know where you are. You're home and you have things to do.

But today you wake up somewhere in between.

It starts with the birdsong that segues seamlessly from the Todd Rundgren song that is the soundtrack of your dreamtime. Then, at first light, the sun rages through the Venetian blinds, refracts and oddly creates verticality on the walls, and, for a moment, you think you're in a barn. Light ignites and pulses through the cracks between the wall slats and casts its sentinel gaze over your fetal, slumbering curl. You can smell the wood, the dirt floor, the mildewed hay, the oxidized iron of old tools.

You roll over and a semi-conscious reverie momentarily shuttles you over all the places you might be. It could be California. It could be Cambodia. It could be Carolina.

The sun steps up a bit higher and these patterns are now in evidence on the floor. The sunbeams hit the hardwood planks which are now furrows in red-clay mud. Furrows on the brow. As your eyes adjust, sparky flashes of white cottony orbs pepper your field of vision. You blink and they don't go away. You blink again and they are faces, ghosts. You had it right all along, this place is haunted.

Your heartbeat quickens and you're awake. This place is North Carolina. You're in the South and it haunts you. You're home, and yet, you're not. You're in between.

White Gold does this to me. It is a dream. The work burns itself into my memory. It haunts me.

The space of sleep-consciousness and waking dream can be defined as a sort of perfect abstraction. One might even go so far as to call it the perfect abstract space. Regardless of the height or depth of abstraction, art is rooted in time and place. With scope and scale, Sayre has created a landscape. A haunted landscape.

It's a little scary. The pieces come together in a narrative that seems to be a ghost story. It tells the story of those that have gone before us and those that many believe still watch over us. It tells the story of the land on which they toiled and the land on which they died. It tells the story of how their spilled blood and broken bones fertilized and mulched the land and created growth. Growth that some people call the New South.

If you grew up in the South, as I did, you grew up in a place filled with ghosts. The ghost story, in its many forms, is our core narrative, our recurring theme: the past, the land, blood and the inability or the unwillingness to let wounds heal, to erase the marks of trauma, to let go. When we talk of these things, no matter where we are, we are traveling home.

But Asheville's great voice, Thomas Wolfe, told us we couldn't go home again. And he might have been right. Perhaps the most we can hope for is what Walker Percy called a "repetition":

A repetition is the re-enactment of past experience toward the end of isolating the time segment which has lapsed in order that it, the lapsed time, can be savored of itself and without the usual adulteration of events that clog time like peanuts in brittle.

And perhaps that is exactly what art is, especially in relation to a sense of place, and a sense of time past.

Some of the most powerful *images* of place are *literary* rather than visual. They can also be further viewed as counterposed creative forms. *A Portrait of the Artist as a Young Man* is a "painting" of Dublin, *The Moviegoer* is a "movie" about New Orleans, *Trainspotting* is a "murder ballad/love song" to Edinburgh.

White Gold can be viewed through the same lens. It is an "epic poem" and a "ghost story" about North Carolina and the South.

In his novel, *The World Made Straight*, Ron Rash, North Carolina's great bard of darkness and light, has his tragic hero, Leonard Shuler, burdened with the belief that "landscape is destiny." Leonard goes on to ruminate as to whether the peculiar landscape of the North Carolina mountains causes its people to live "in the passive voice... like their lives aren't real but memories":

He'd tried to make sense of the notion that time didn't so much pass as *layer over things*, as if under the world's surface the past was still occurring.

The historical event that is the genesis of Rash's story is the Shelton Laurel Massacre. Sayre's barns and furrows echo here.

In 1863, in Madison County, thirteen men and boys, ranging in age from 13 to 70, were rounded up by Confederate soldiers and held prisoner in one of their own barns. In the bitterly cold January morning they were marched out and mowed down among the frozen furrows of one of their own fields before they could coax the corn or yams or tobacco out of it. Their blood would fertilize the land for further generations of hardscrabble yeoman farmers to till.

The tragedy here is minute in scale when compared to the inconceivable, vile, epic genocide of American slavery. And yet it is no coincidence that the men and boys who died at Shelton Laurel were North Carolinians who refused to side with the slaveowners. King Cotton could issue murderous decrees, but many, many refused to follow them and, instead, perished.

And so you can see their faces in Sayre's cotton, dozens of faces that, at different angles, morph from friend to enemy, from stranger to kin, from oppressor to oppressed, master to slave, murderer to victim.

This evocation is not limited to the time past of the American South. When I first set my eyes on *White Gold* it didn't take long before tragic images tied to the bloody earth from my other "home" were evoked.

In Southeast Asia, in Cambodia, the Killing Fields was the name given to the muddy, poxed landscape where the Khmer Rouge massacred one million, three hundred, eighty-six thousand, seven-hundred and thirty-four of their fellow Cambodians in the name of "re-education." This was a genocide in the name of an ideology, where the fields were filled with killing because of how people *thought*; men and women, boys and girls; sisters, mothers, fathers, brothers. Another million died from starvation and disease. That's two and a half million out of a population of eight million. Ghosts. Faces in the fields.

So here, too, just below the surface of modern growth, in the villages of Tuol Sleng and Chuong Ek and a dozen others, the furrows are filled with blood and the barns and buildings look on as sentinels and hold their ground as the guardians of memory.

Do the ghosts watch over us as we sleep? Do the furrows and the faces lead us home or *away*? Have we escaped or do we have things to do? Or are we somewhere in between? ∎

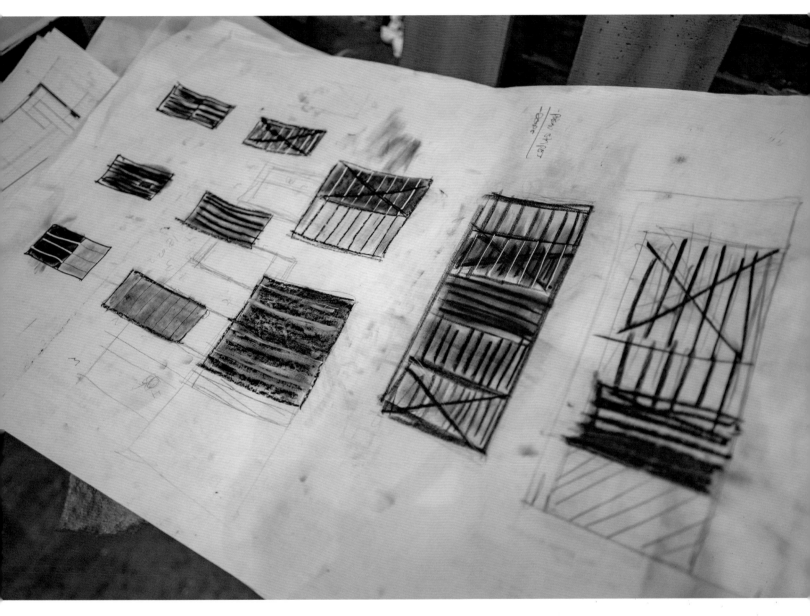

Charcoal sketches for the *Barn* series in *White Gold*.

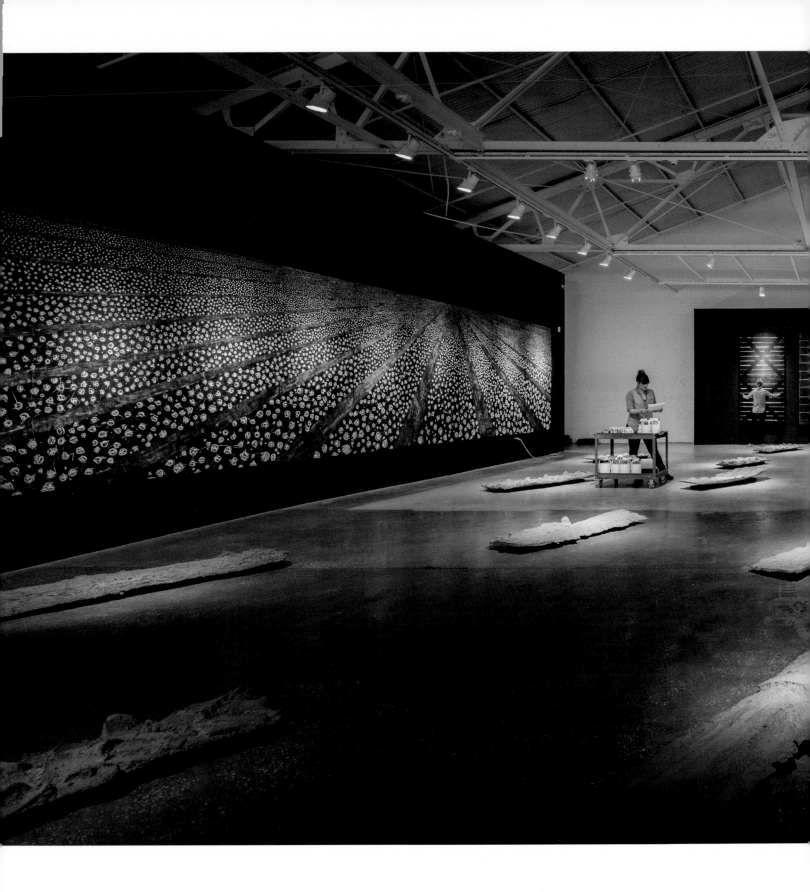

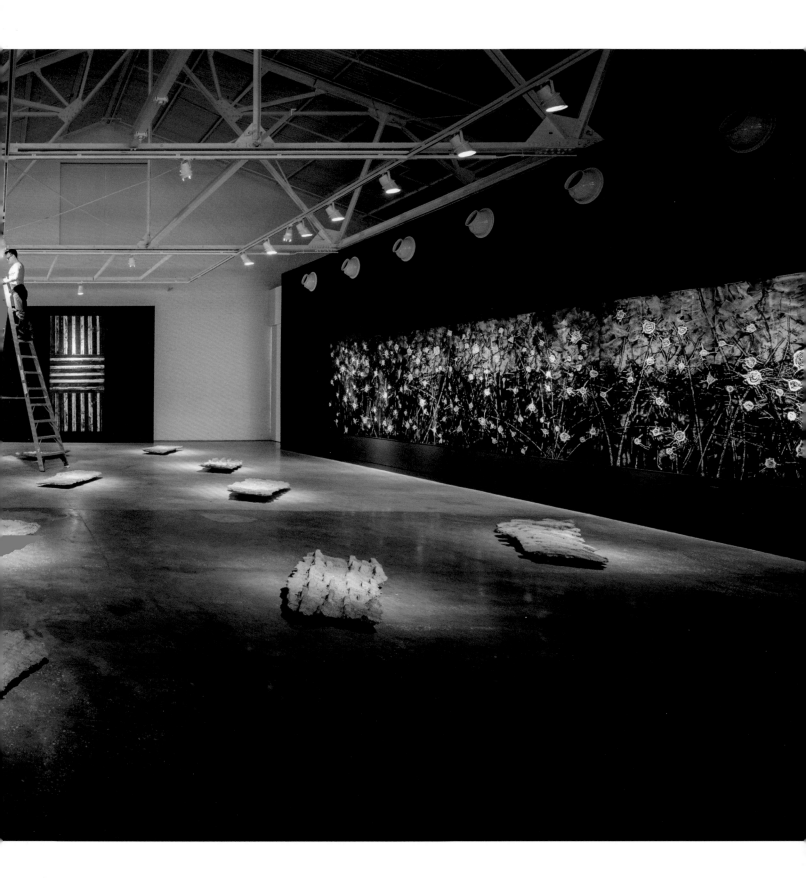

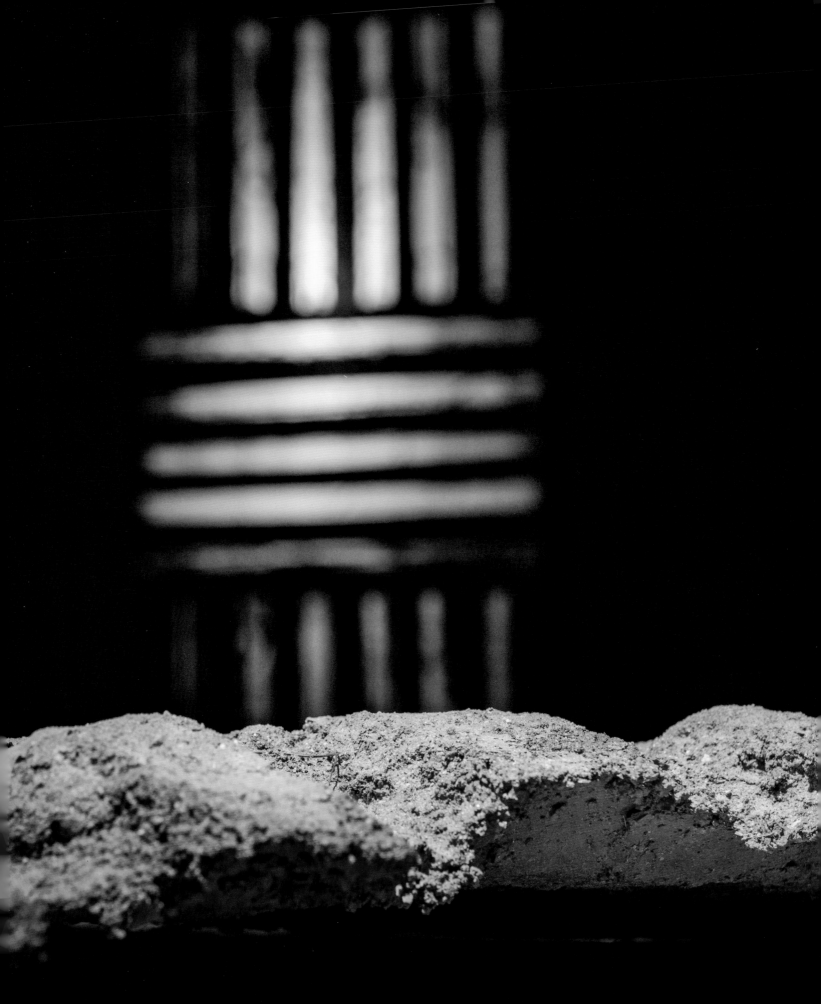

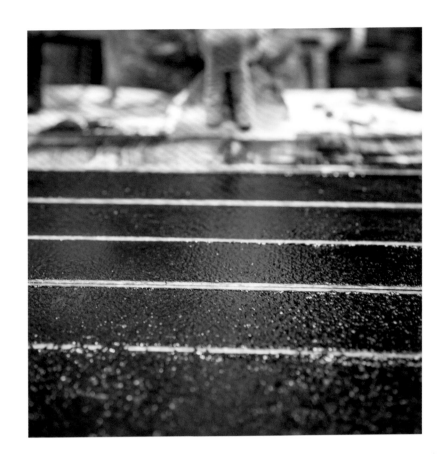

LANDSCAPE

by Howard L. Craft

Landscape
Branches birth snow
From green bulbs bursting brilliant
Cotton bright blinding

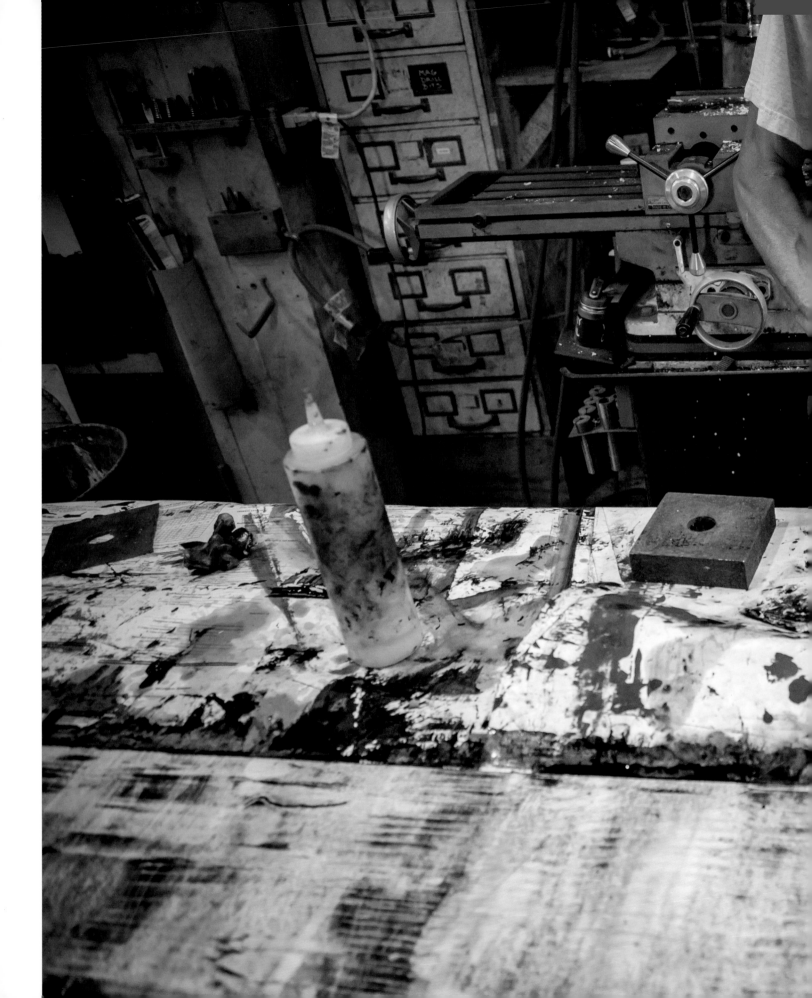

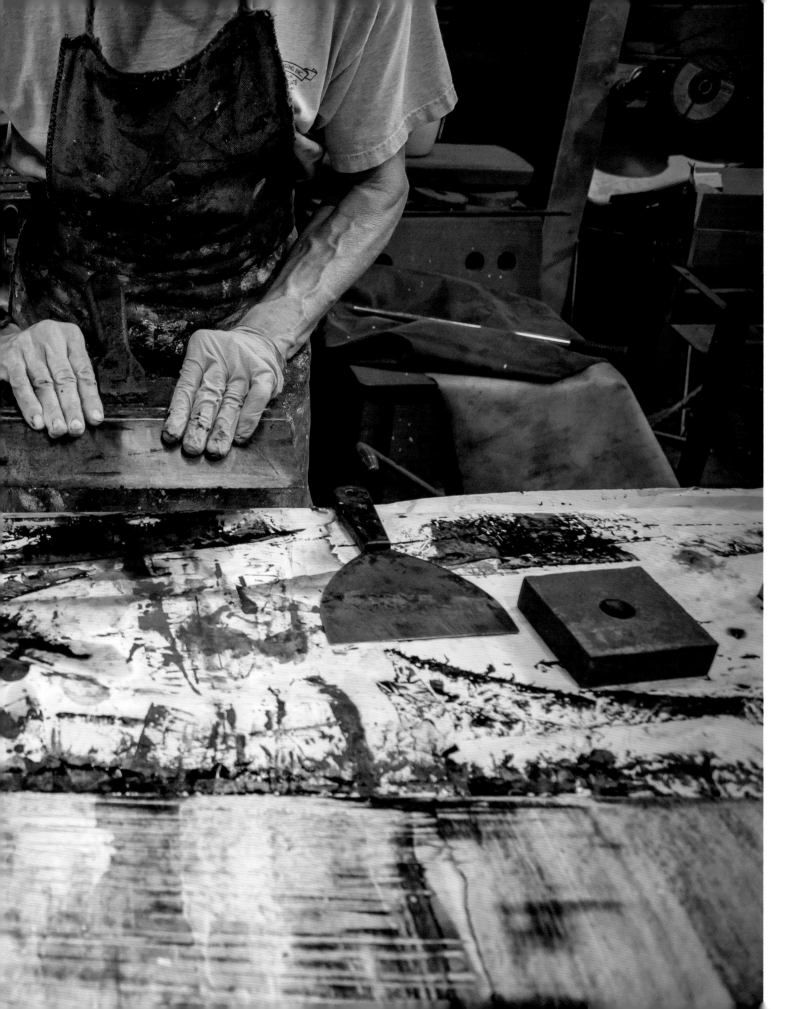

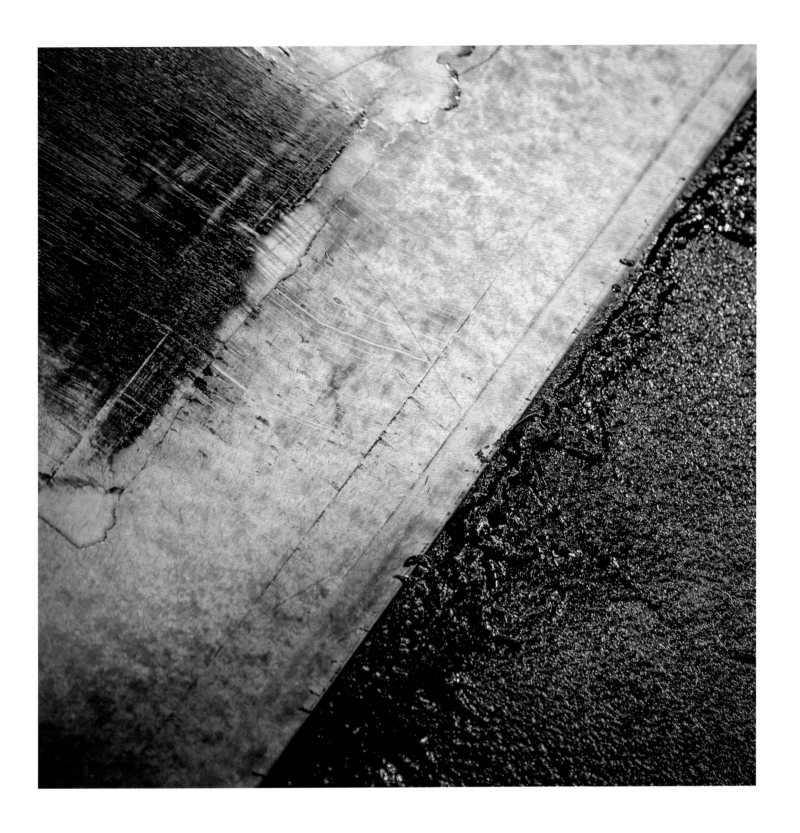

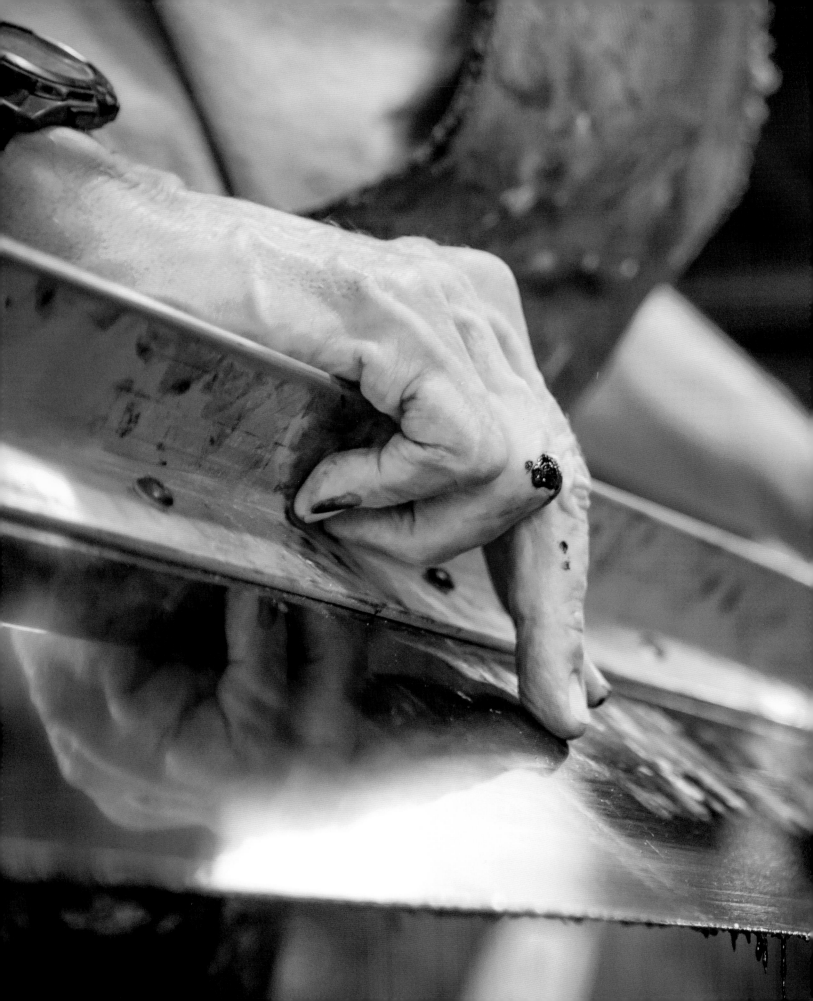

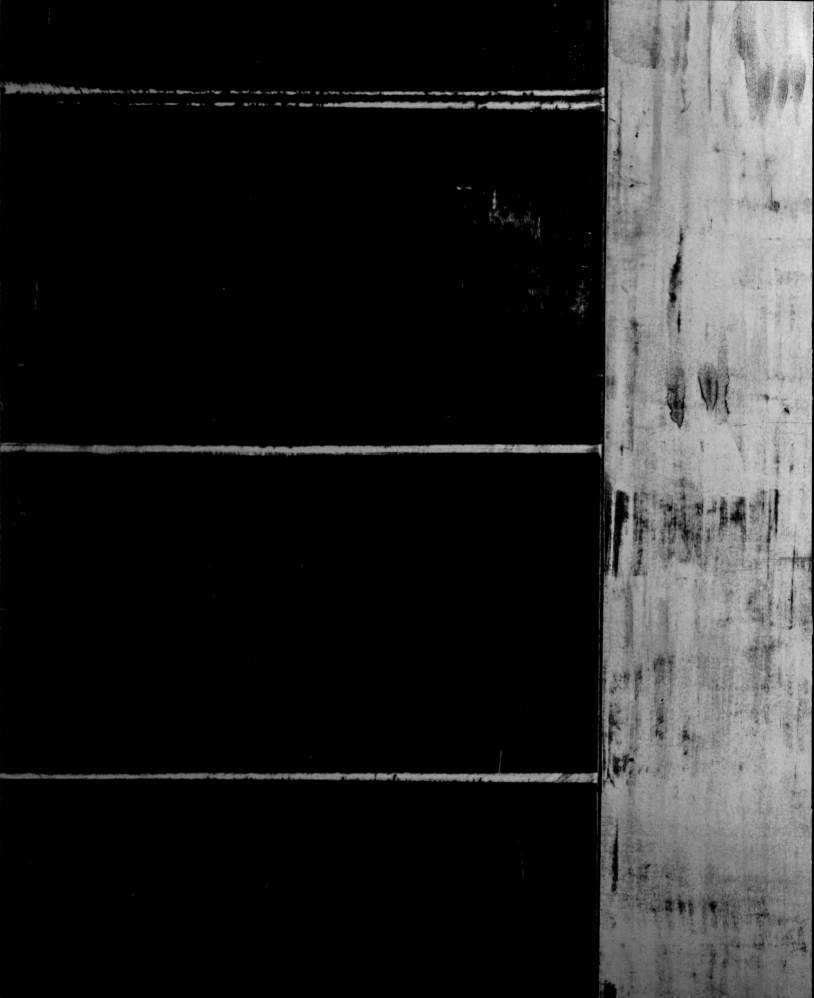

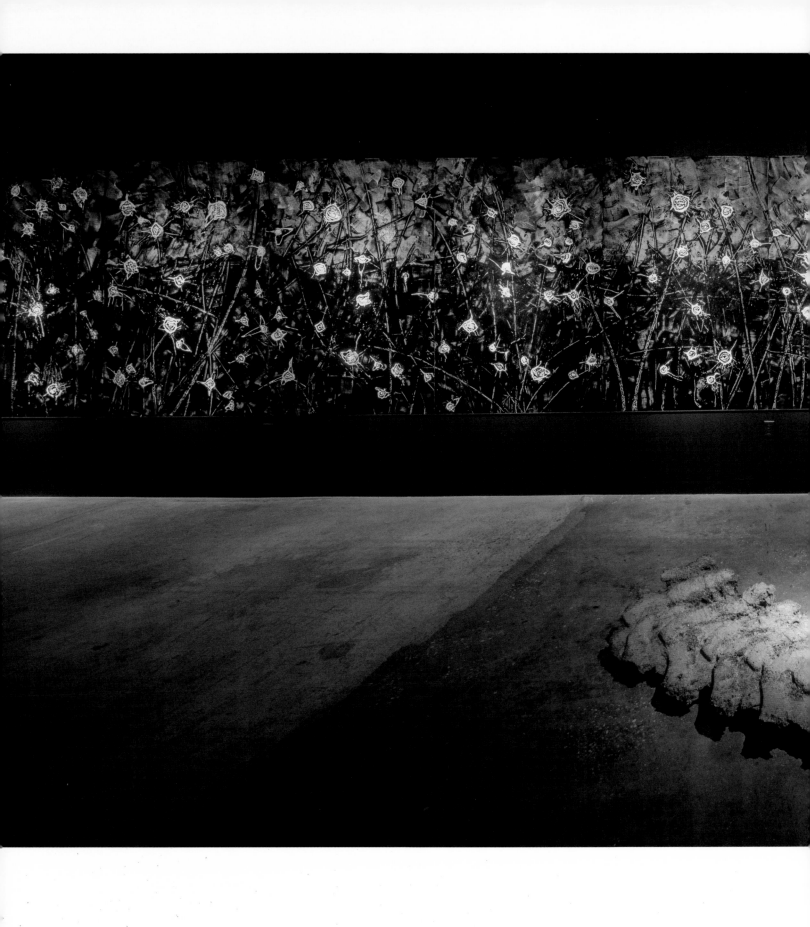

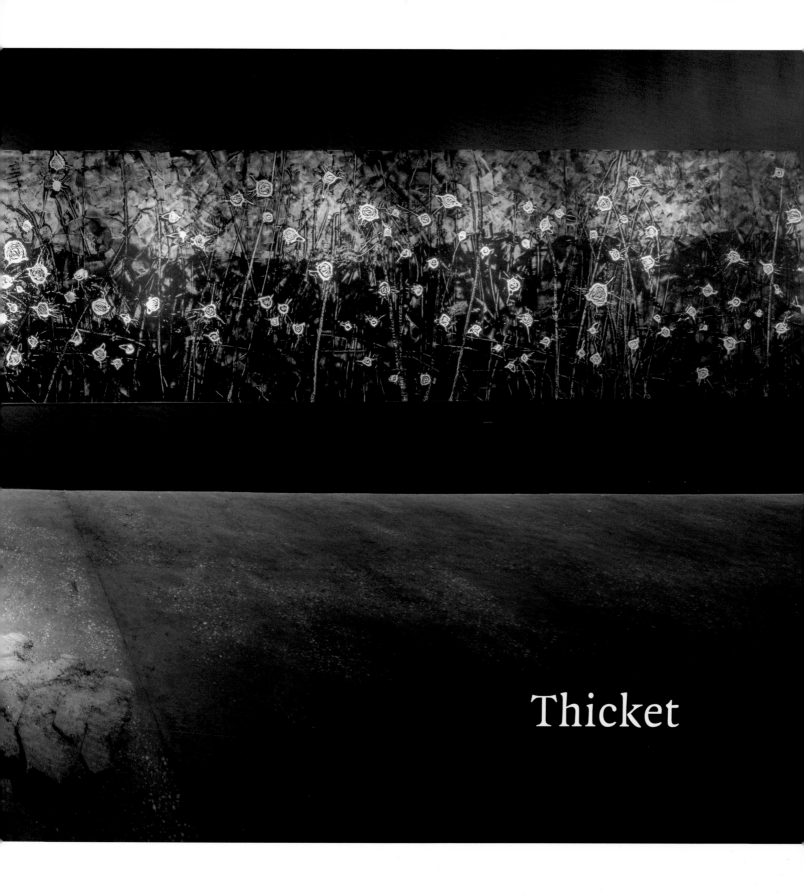

Thicket

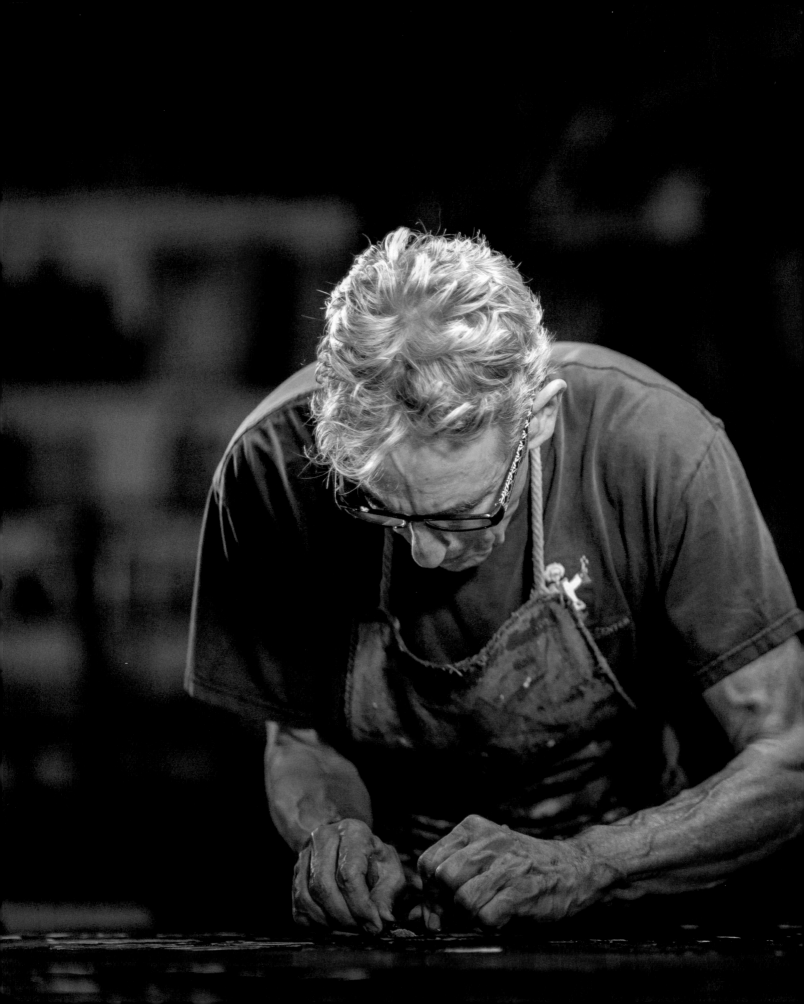

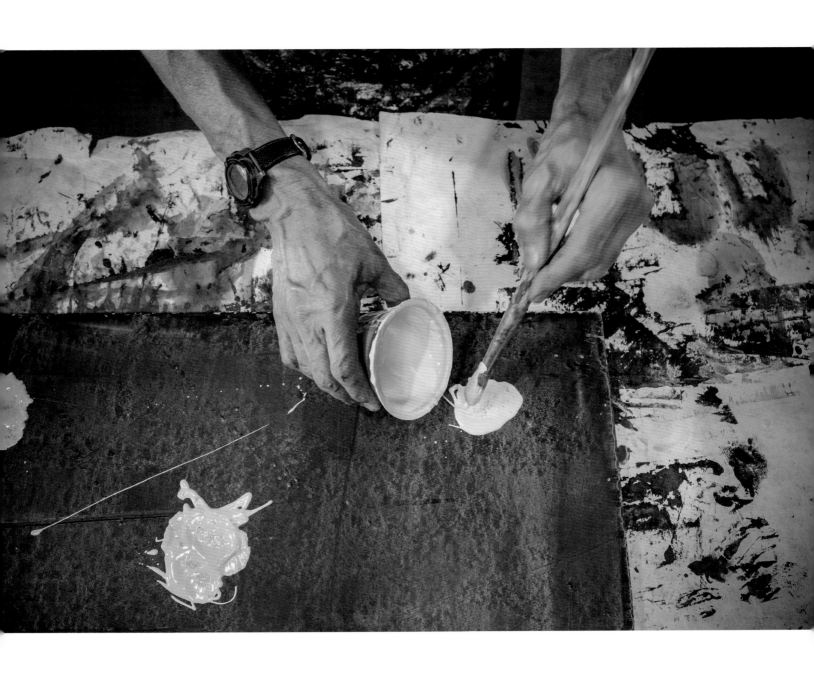

DIXIE

by Howard L. Craft

Land O' Cotton
Picked by slaves and tenants
Blood soaked ground

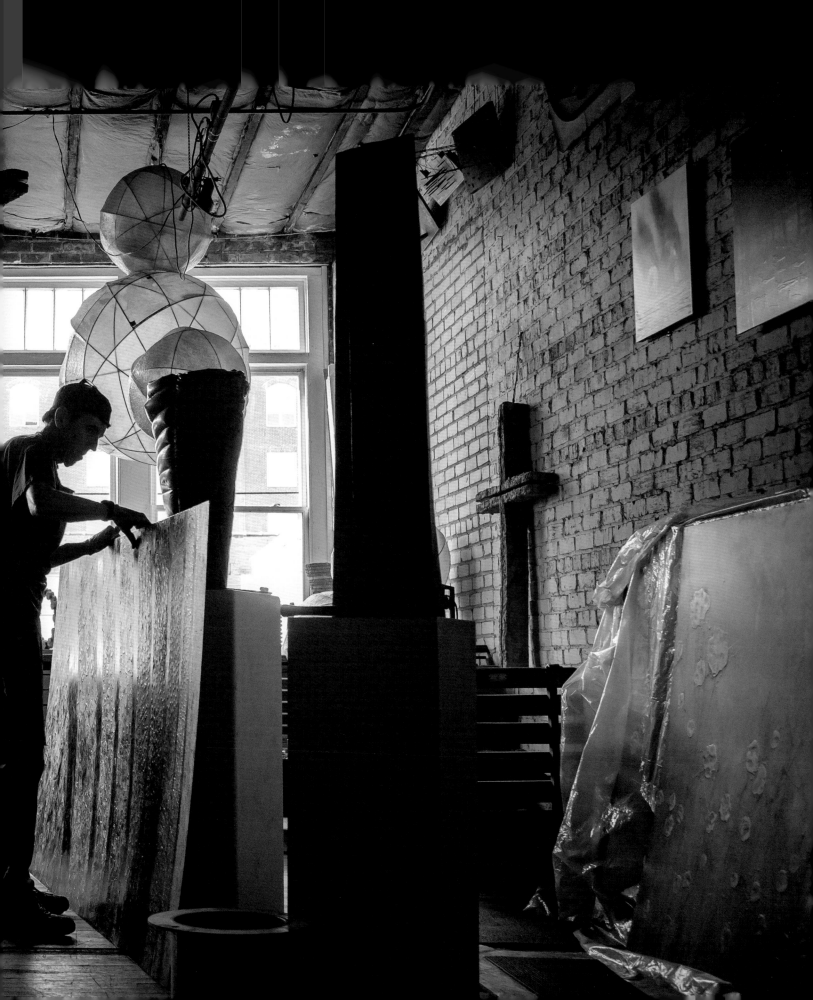

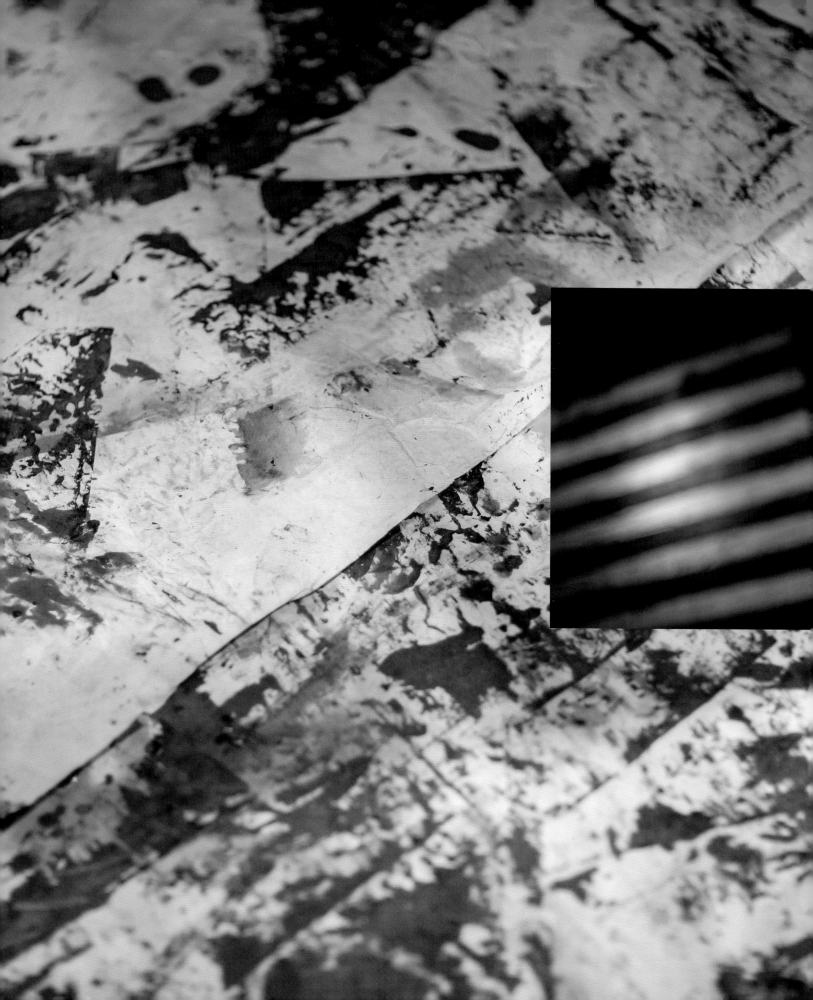

COTTON TALES: THANKSGIVING 2014

by Howard L. Craft

The trusty Honda Accord sails across the black river of asphalt while rhythm and blues belches from car speakers. A family of three—my wife, my young son and I—head toward Halifax, North Carolina. Having already arrived at Grandma Cheek's house, my aunts make the final preparations for the holiday meal. My uncles surround the TV and watch the Detroit Lions lose, which is as traditional as the Charlie Brown Thanksgiving Day special with Snoopy in a Pilgrim hat. I have a meeting with a turkey that I do not intend to be late for, and so I press the gas pedal a little harder. I know my wife's eyes are saying, "You're going to mess around and get a ticket," so I look straight ahead to avoid the steely stare. She's going to have to vocalize this warning.

I turn off onto one of the river's tributaries, a winding country road, confident that the GPS isn't leading me astray as the scenes change: an old Exxon Gas station, and then miles and miles of fields and farmland that I'm oblivious to. All I'm seeing is the large ›

› plate of delectable goodness that is in my immediate future when my four-year-old sounds off from the car seat.

"Daddy, what's that white stuff?"
"What white stuff?"
"All over the ground."
"Where?"
My wife responds, "He's talking about the cotton, and you need to slow down."
"Like cotton candy at the State Fair, Daddy?"
"No, it's a plant."
"What kind of plant?"
"The kind your ancestors use to have to pick."
"What are ancestors?"
"People who picked the cotton."
"Howard, give a better explanation than that," says my wife.
"Why did they have to pick it?"
"It's complicated."

Shamefully, lacking a better explanation, or rather one that I could immediately put in words that a four-year-old could understand, I pass my son the iPad and little yellow Minions consume his curiosity for the rest of the trip. But he's not going to let it go. He will come back with his questions, as is his way, and I'll need to have an answer when he does.

One of the challenges of being an African American is that everything about the history of the United States is complicated with regards to Black people. The Founding Fathers were slave owners. The constitution stated that Blacks were only 3/5 of a human being. The national anthem was written by a slaveholder who in the anthem celebrates the death of slaves who fought with the British for a promise of freedom; that part is excluded, of course, when we sing it today. And cotton, this seemingly innocent-looking plant, from which everything from clothes to greenbacks was made, a crop that made America a world power and was the backbone of the British Empire's economy, for Black people, holds a darker, crueler narrative.

Before the invention of the cotton gin in 1793 slavery was on its way out. The morality of slavery was questioned, even in the south; it was viewed as an outdated and backward institution. Its economic feasibility made less and less sense, as the profit margins plantation owners were able to make from slave labor, versus the amount spent on maintaining slaves for the crops the slaves produced, had dwindled radically. It took a slave ten hours to pick the seeds from one pound of lint. This made cotton a very unattractive cash crop. Enter Eli Whitney and his cotton gin, which was capable, as Whitney put it, of allowing "one man with a horse to do more than fifty men with the old machines," and the attractiveness of the cotton enterprise changes dramatically.

To add to that change the industrial revolution got underway in Britain. American cotton fueled it, and slavery, instead of ending, boomed. America went from 700,000 slaves in 1790 to over three million by 1850. By 1861 one of every three southerners was Black. Slavery would last until 1865—another seventy-two years—as the result of America's and Europe's desire for cotton. The misery, torture, and loss of life—from Africa to the Middle Passage to the ramped up internal US slave trade—is truly immeasurable.

A slave's life in the American South had never been one of ease, but slaves who worked on cotton plantations endured a special kind of hell. They worked from dawn until late in the night, driven like animals by overseers with bullwhips, and they were given just enough food to survive in order to make it back to the fields the next day. But the story of African Americans and cotton doesn't end there, as many freed blacks became virtual slaves through the systems of share cropping and tenant farming. This allowed white plantation owners to exploit their labor and lock them to the land through debt; terror, by means of lynching and the Ku Klux Klan; or by throwing them off the land and then imprisoning them for vagrancy in plantation-styled prisons. Some of these prisons still exist today. Angola, or Louisiana State Penitentiary, is the largest state prison in the country. It is 18,000 acres of land where convicts, eighty percent of which are Black, pick cotton under armed guards on horses with shotguns. In 2016.

So how do I feel about cotton, and what do I say when my four-year-old asks why did our ancestors have to pick it? How do I get past just saying it's complicated? I will tell my son, "your ancestors, your people, are survivors, and no matter what they have faced in America they have found a way to overcome it. Cotton is another symbol of that, and it reminds us of the dogged determination that our people possessed—and still possess—which enables us to strive towards better and brighter days." ∎

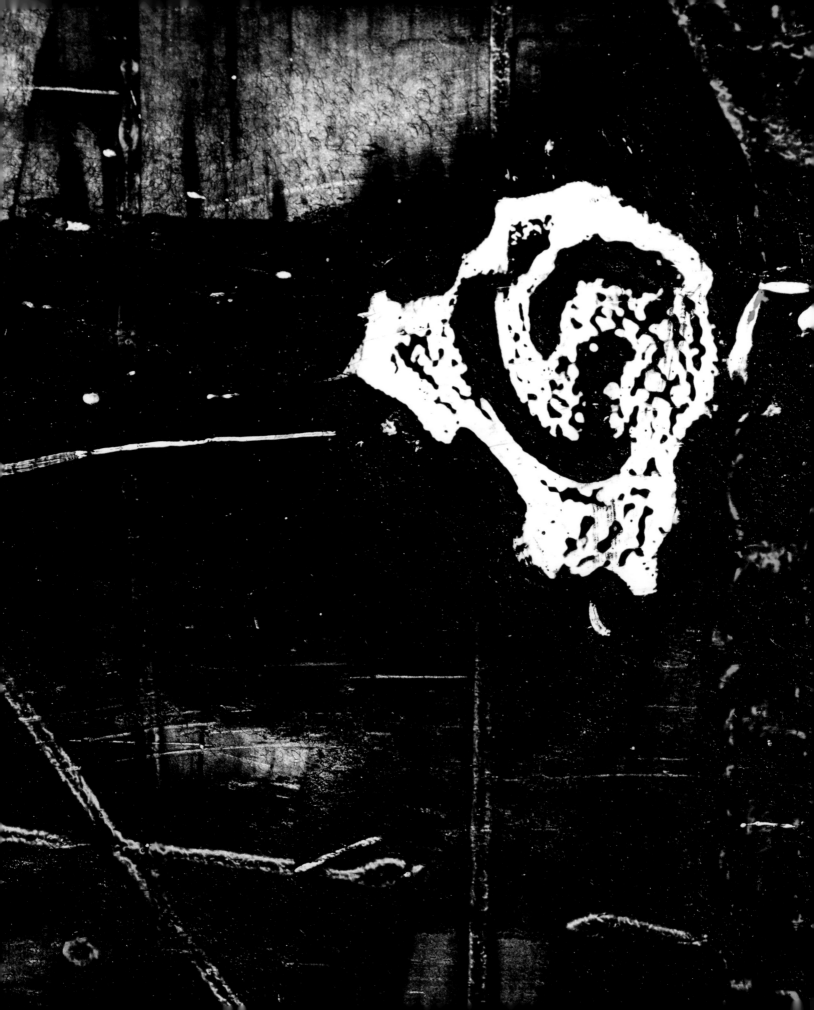

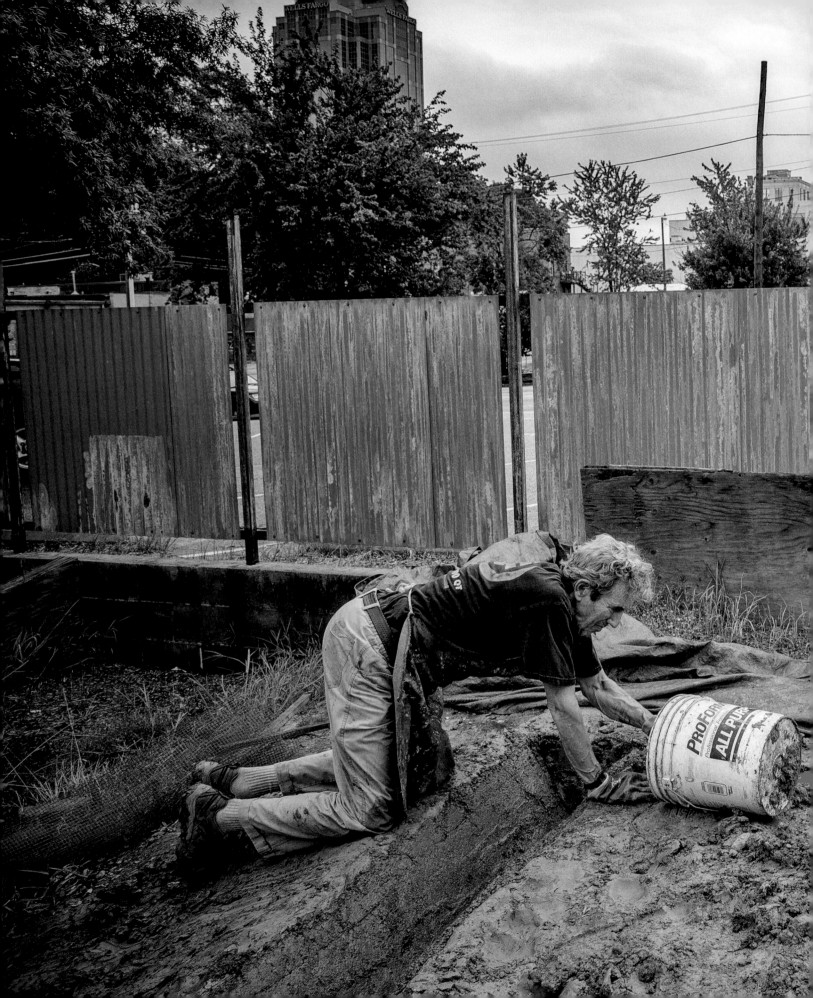

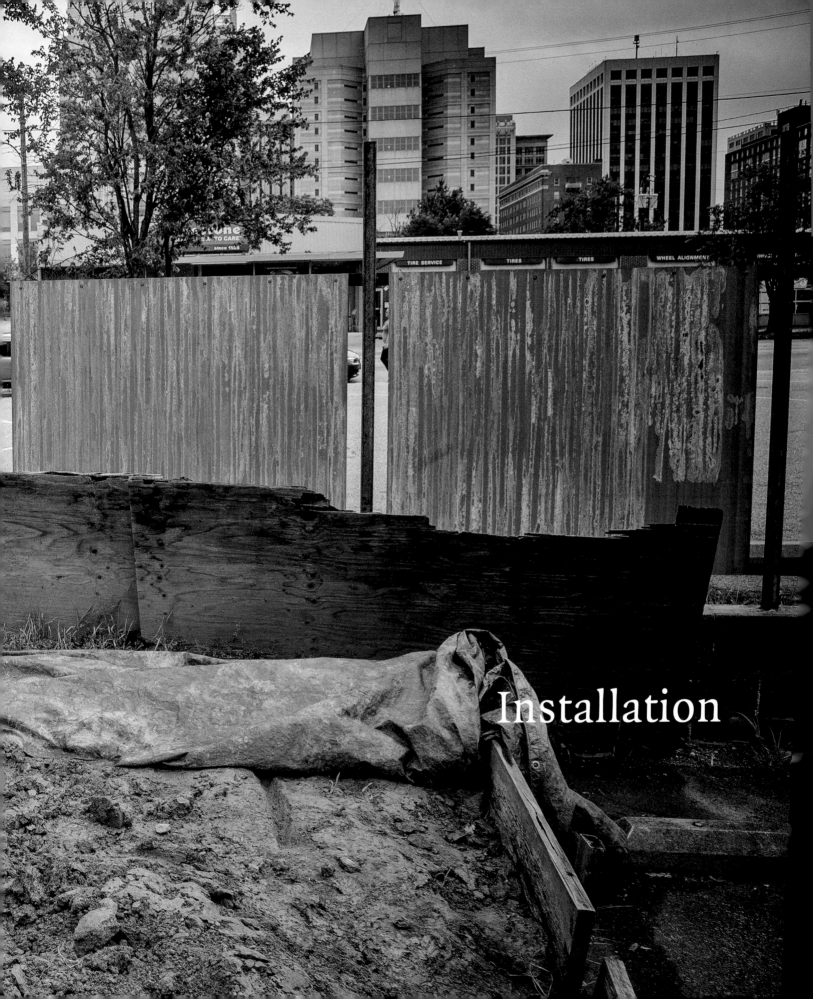

Installation

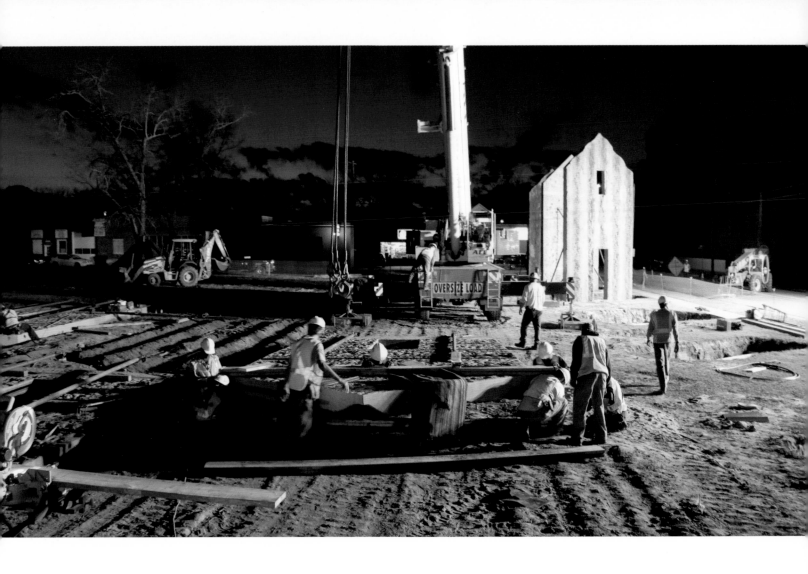

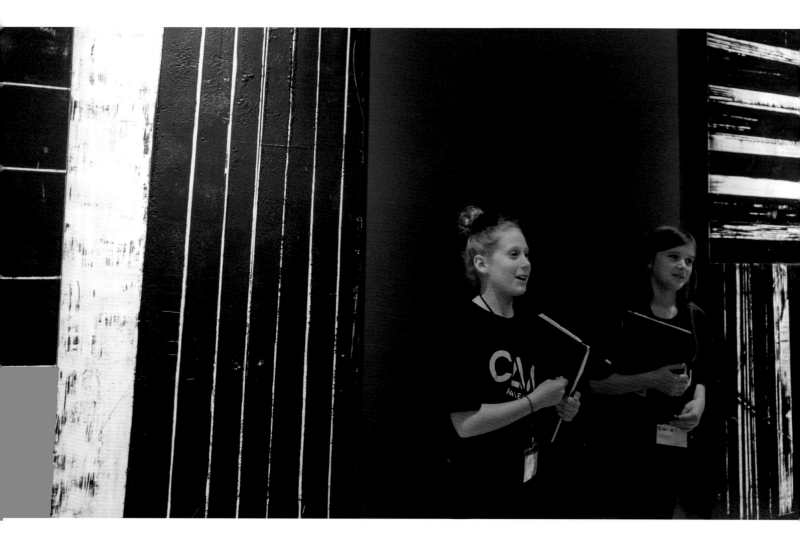

Sayre's *Flue* earthcasting in downtown Kinston, North Carolina (left), reflecting an ongoing interest in the barn structure which is evident in the *Barn* series of paintings in *White Gold* as well (photo courtesy Minnow Media). Above are two of CAM Raleigh's middle school docents on opening night in front of the *Barn* series of paintings.

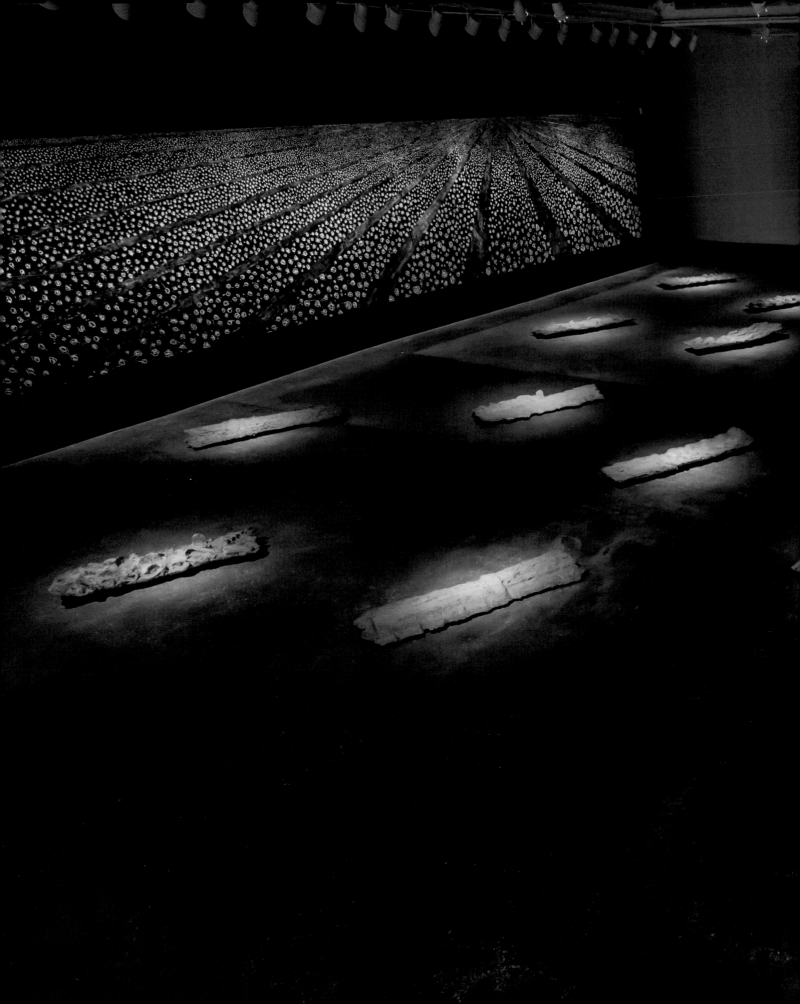

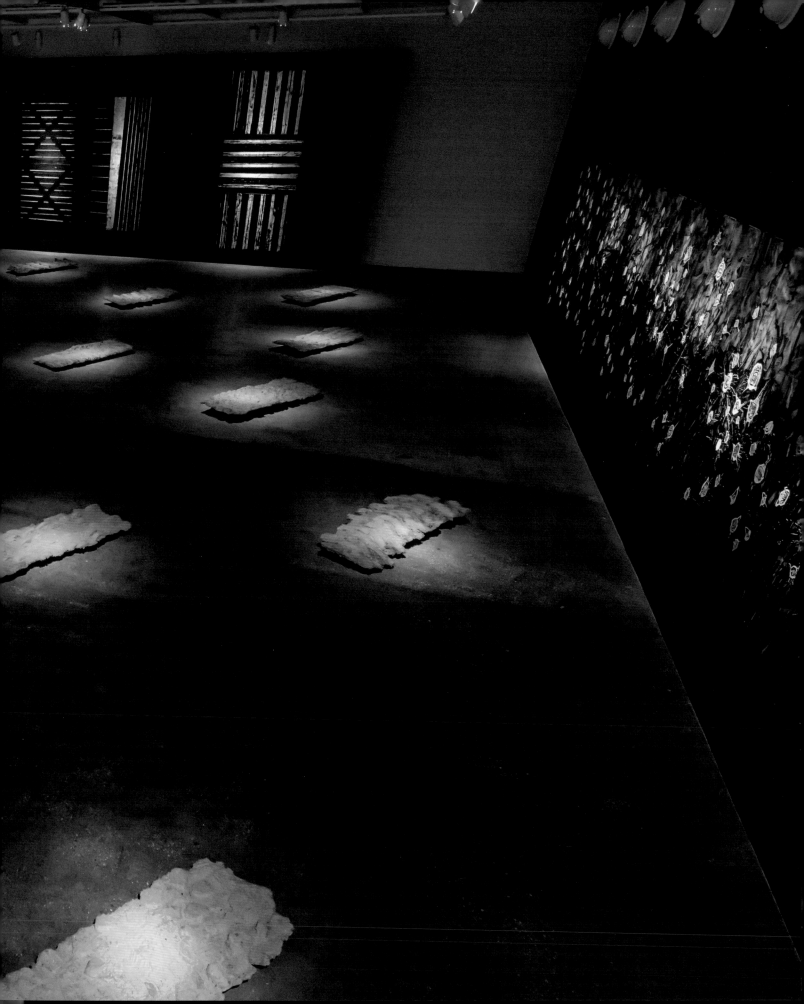

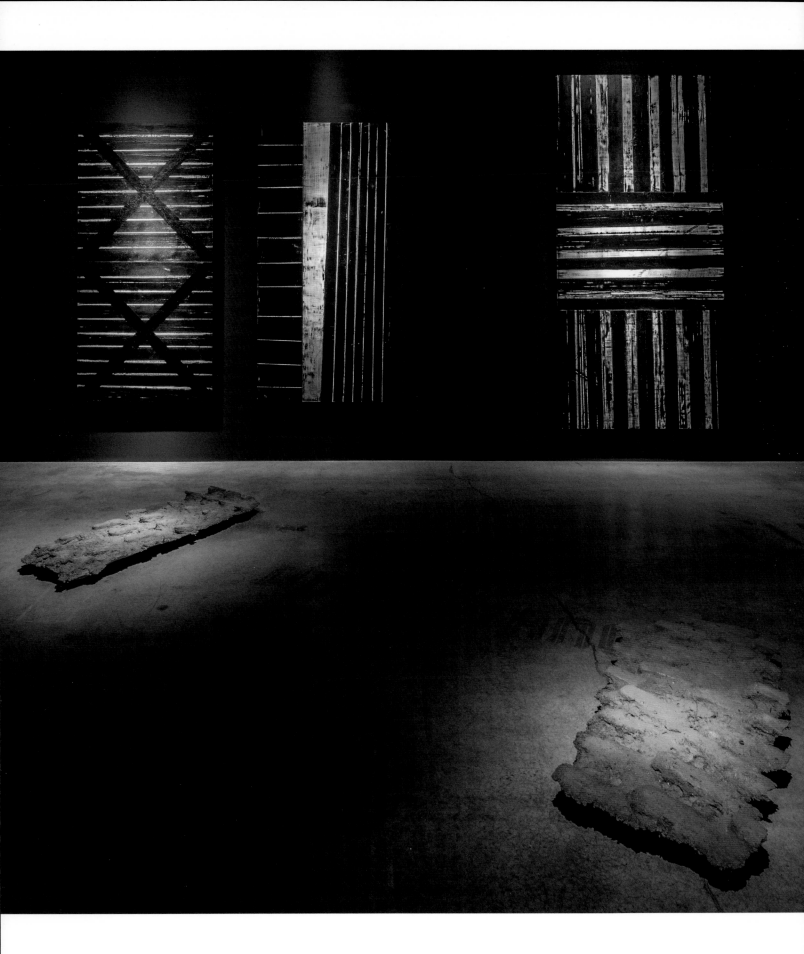

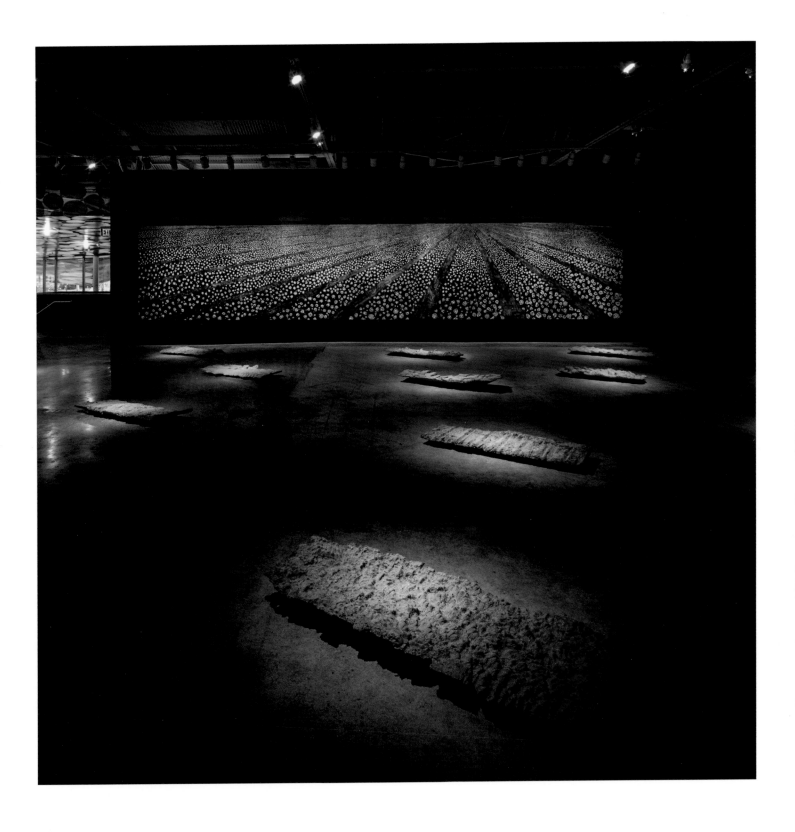

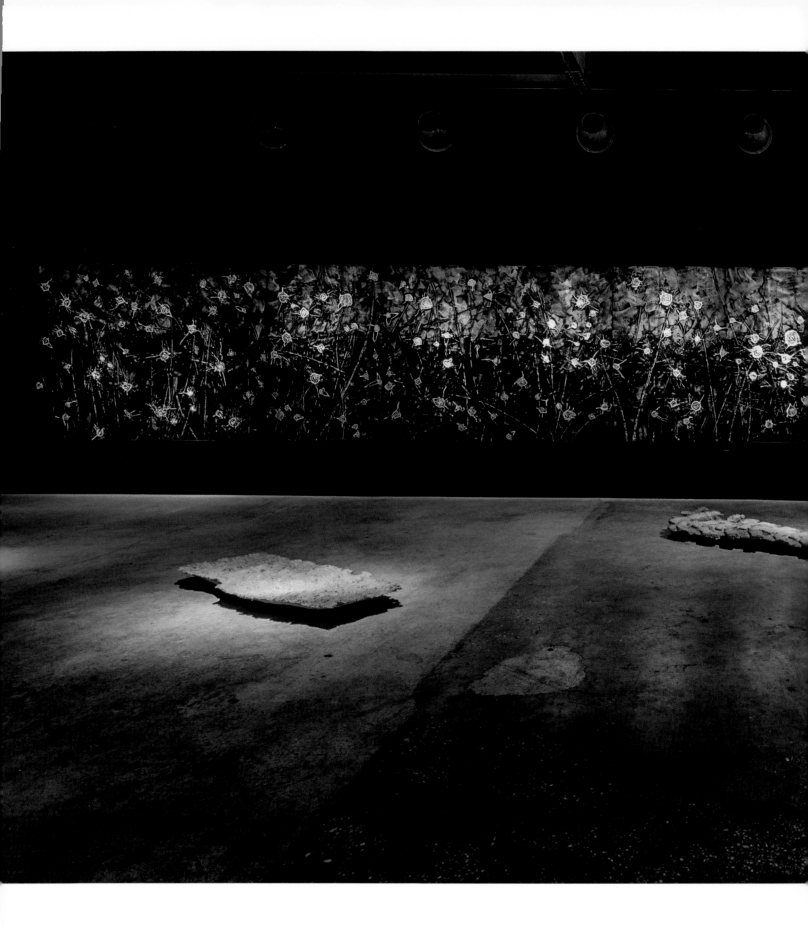

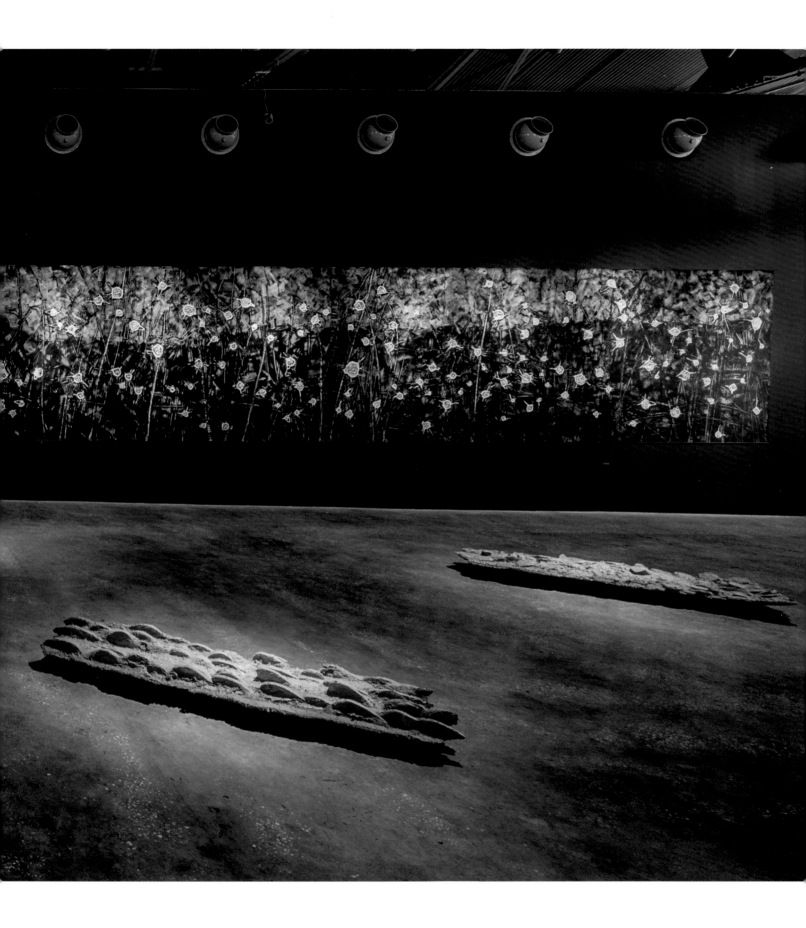

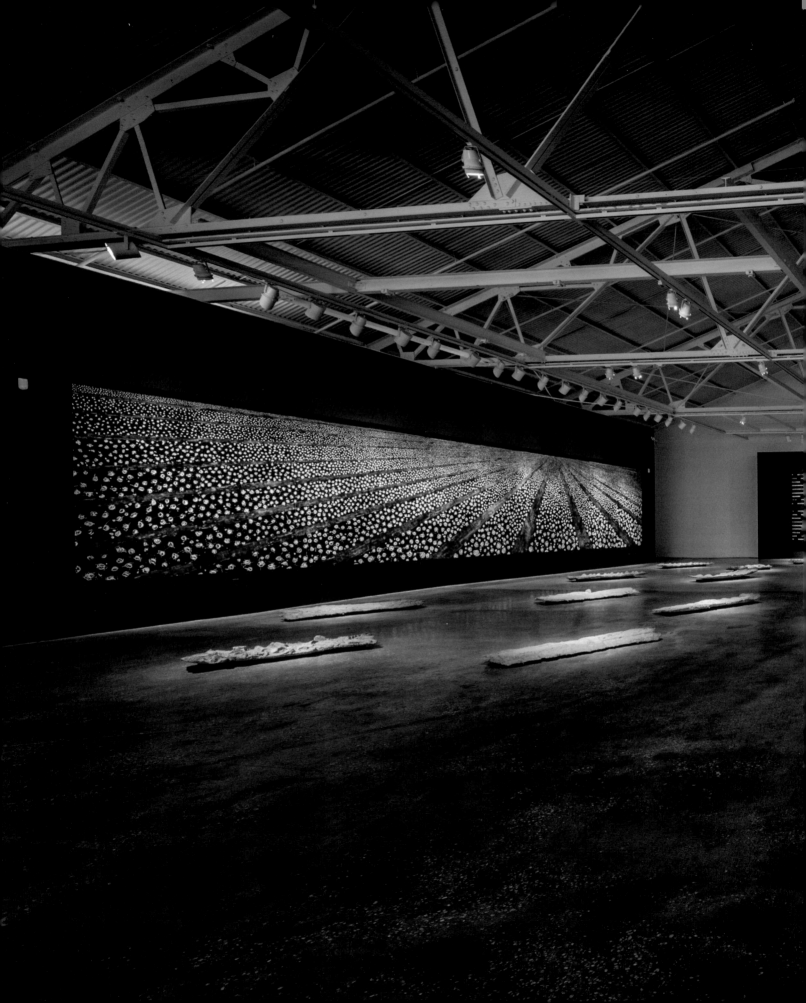

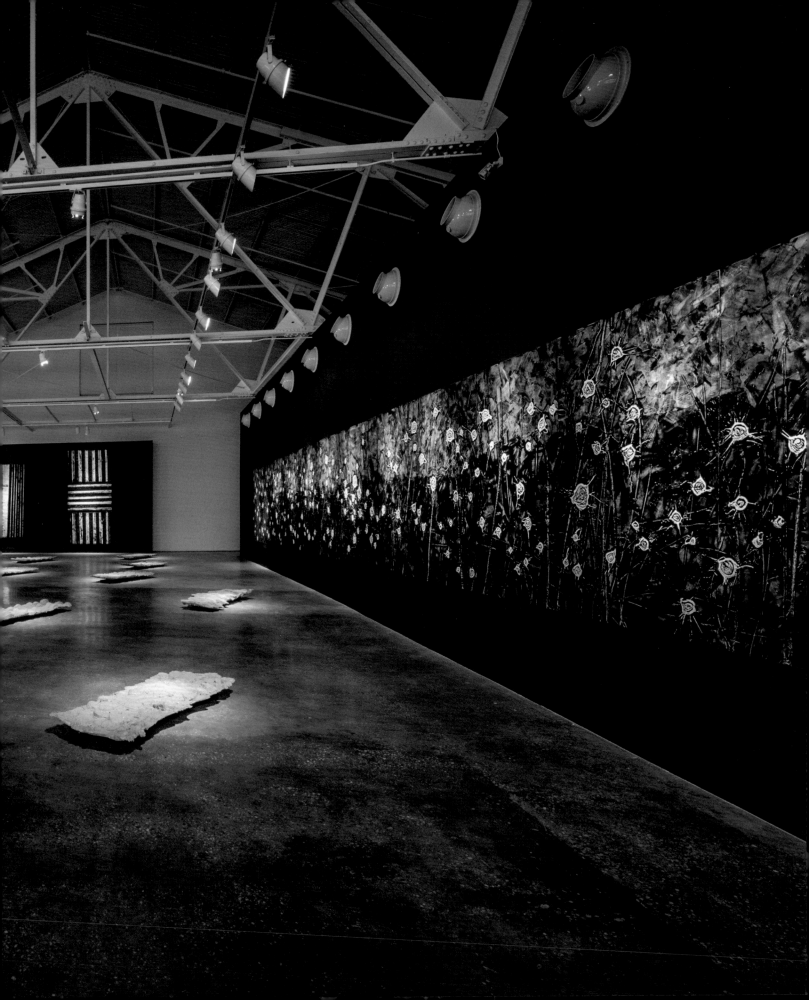

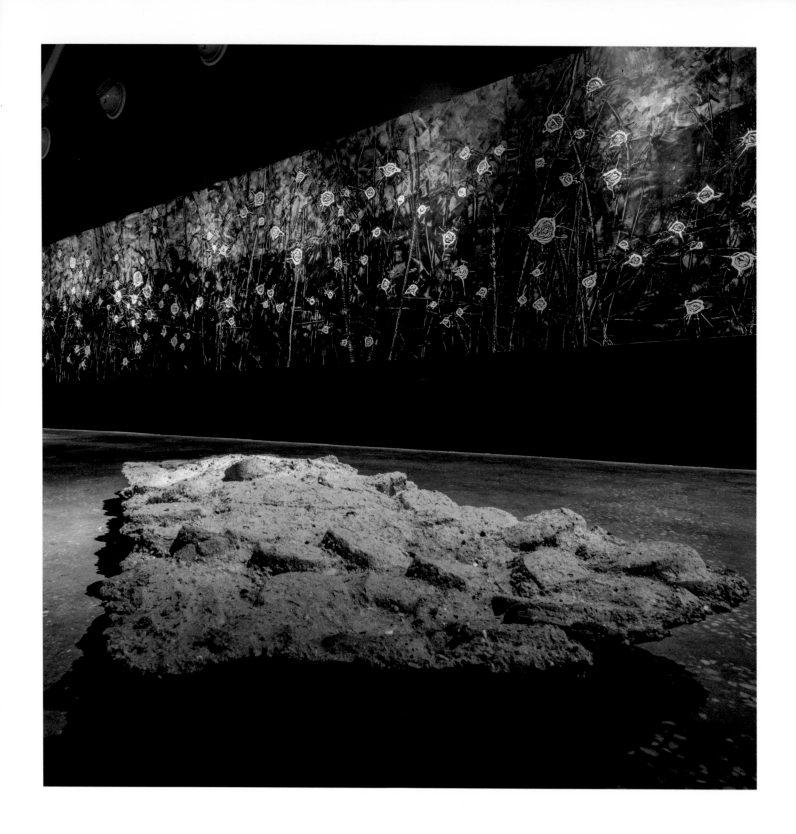

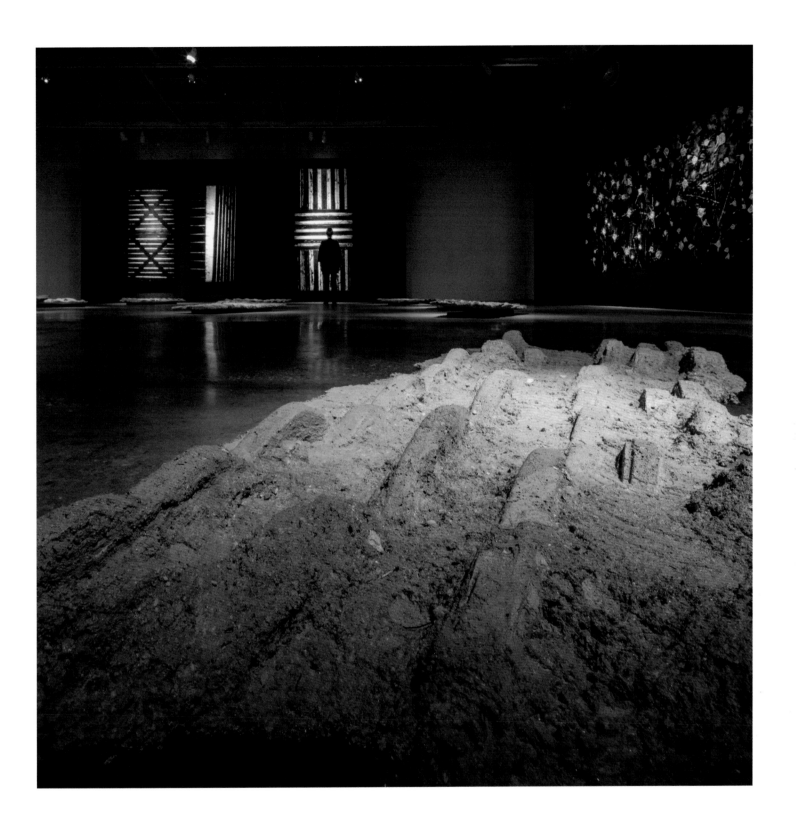

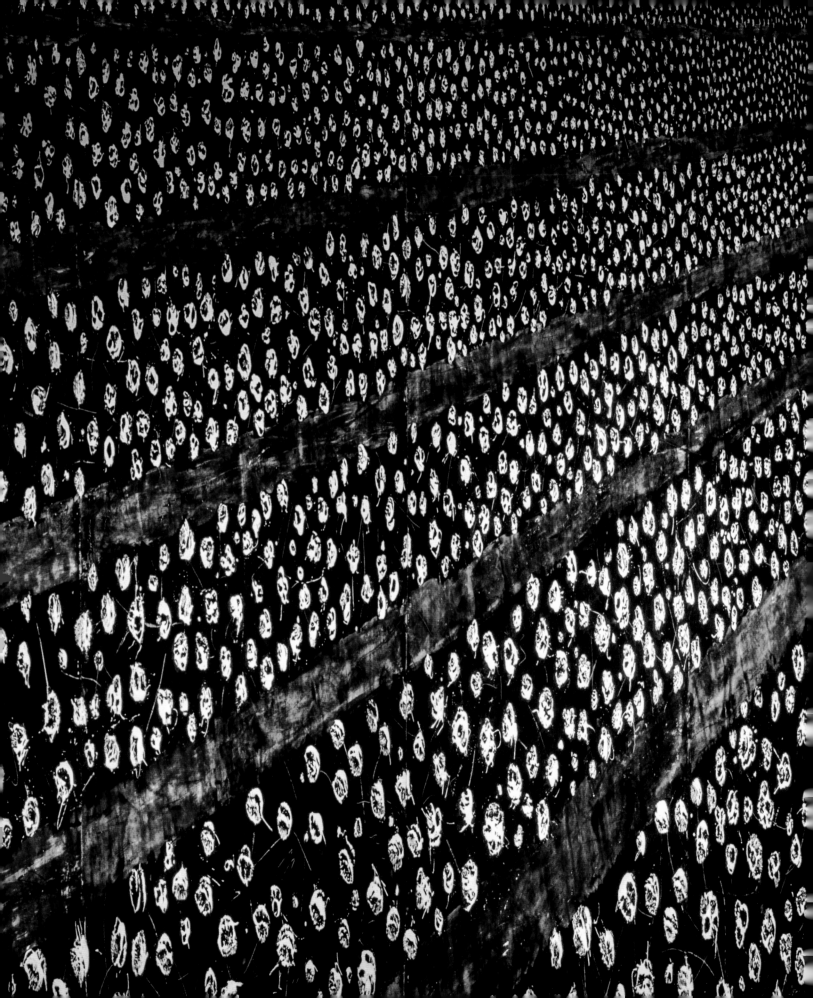

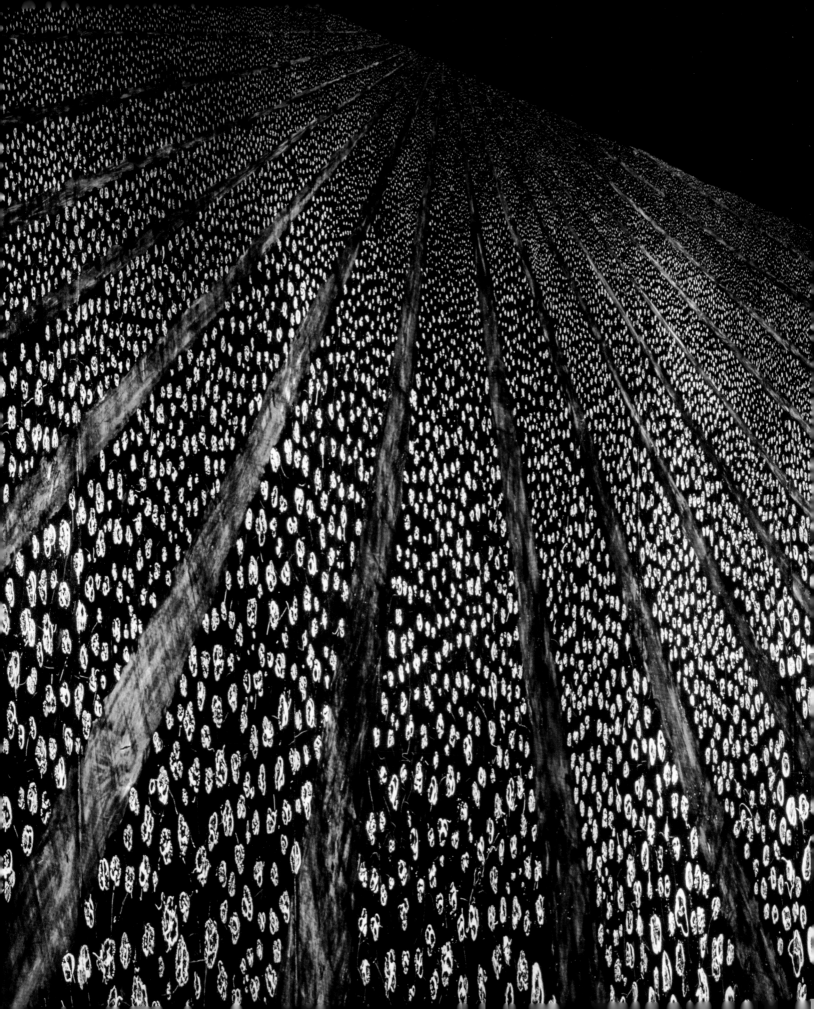

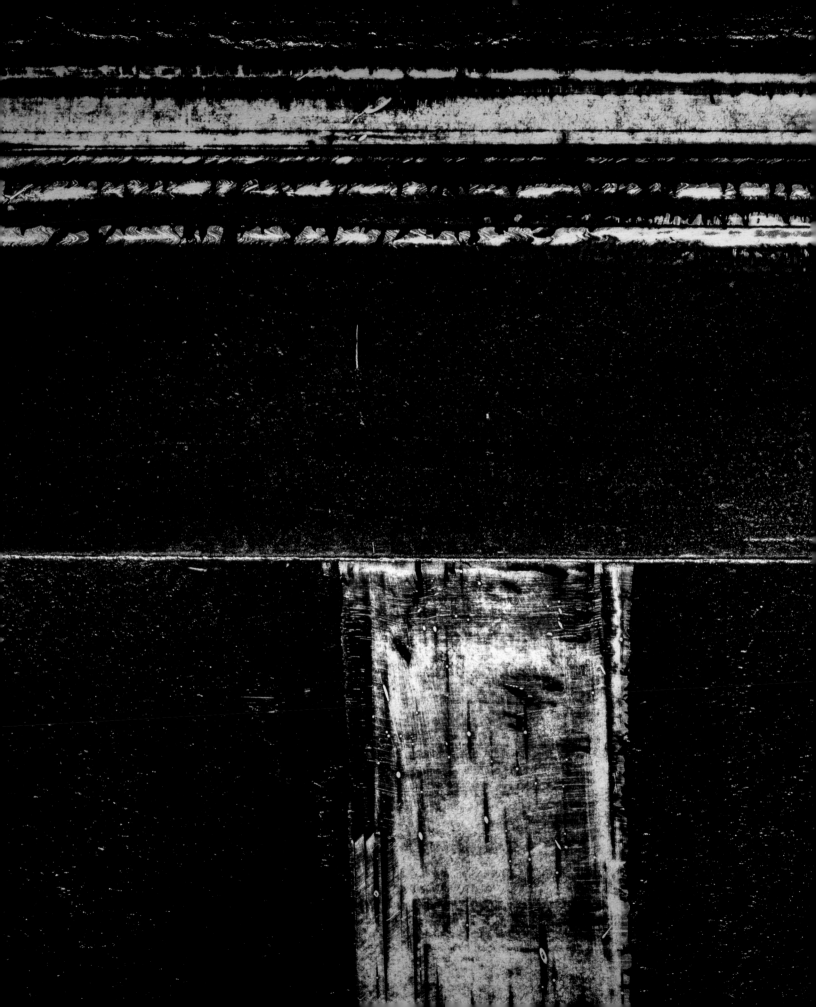

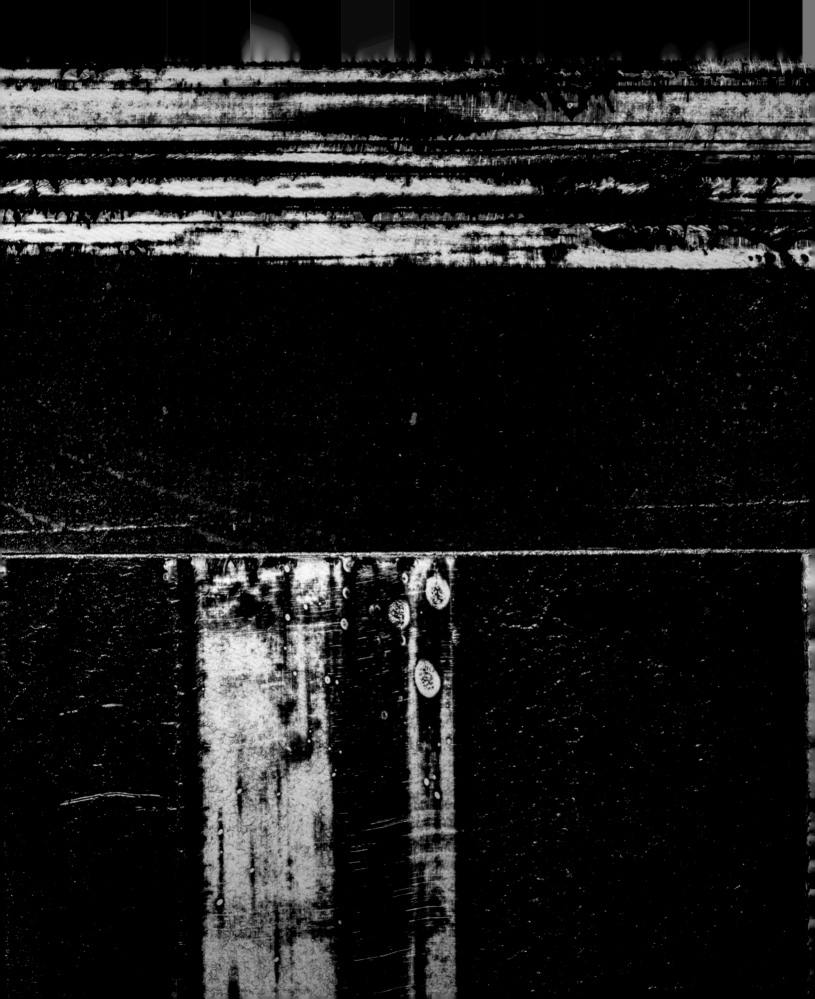

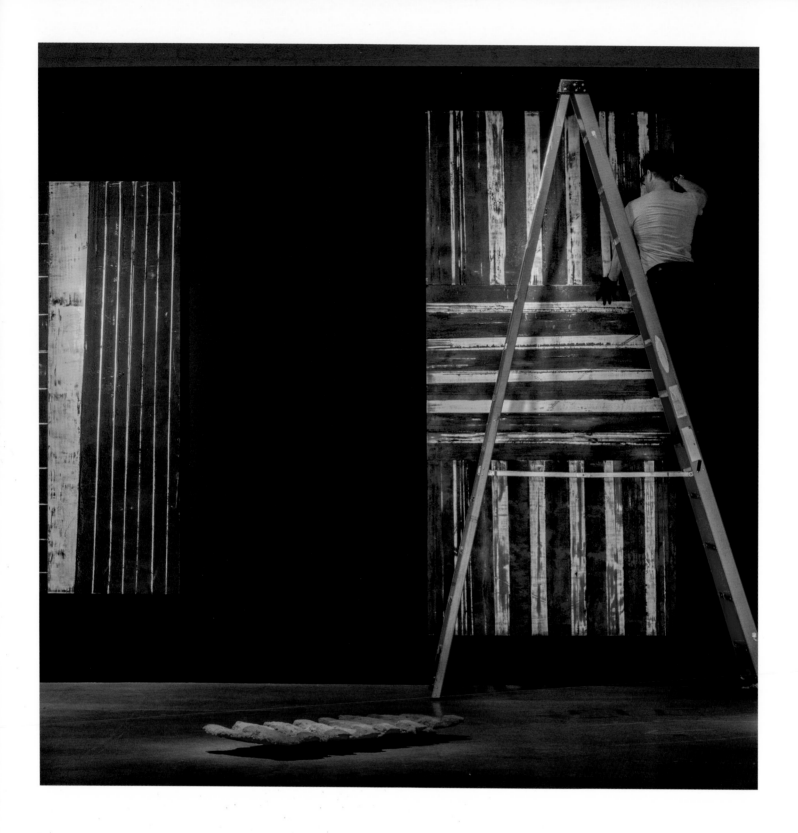

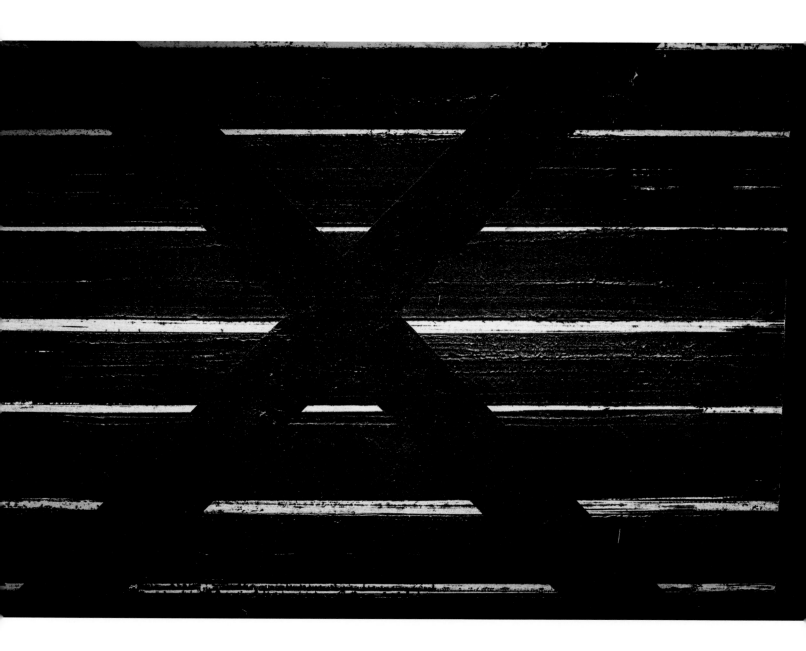

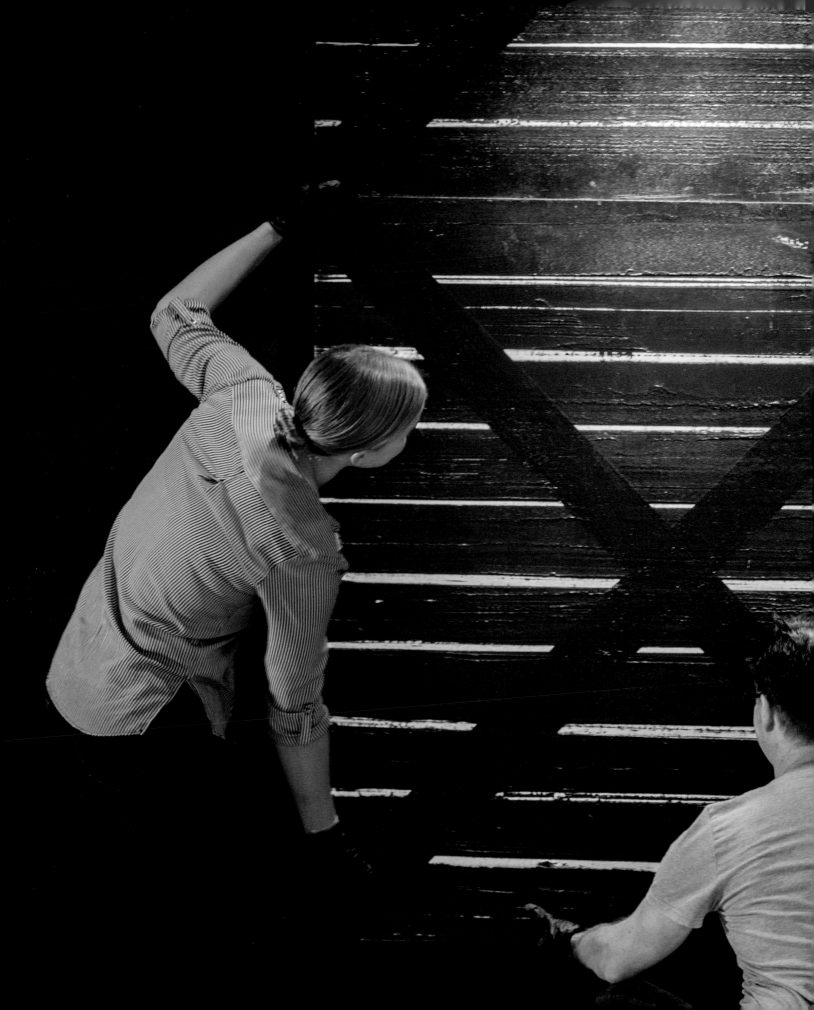

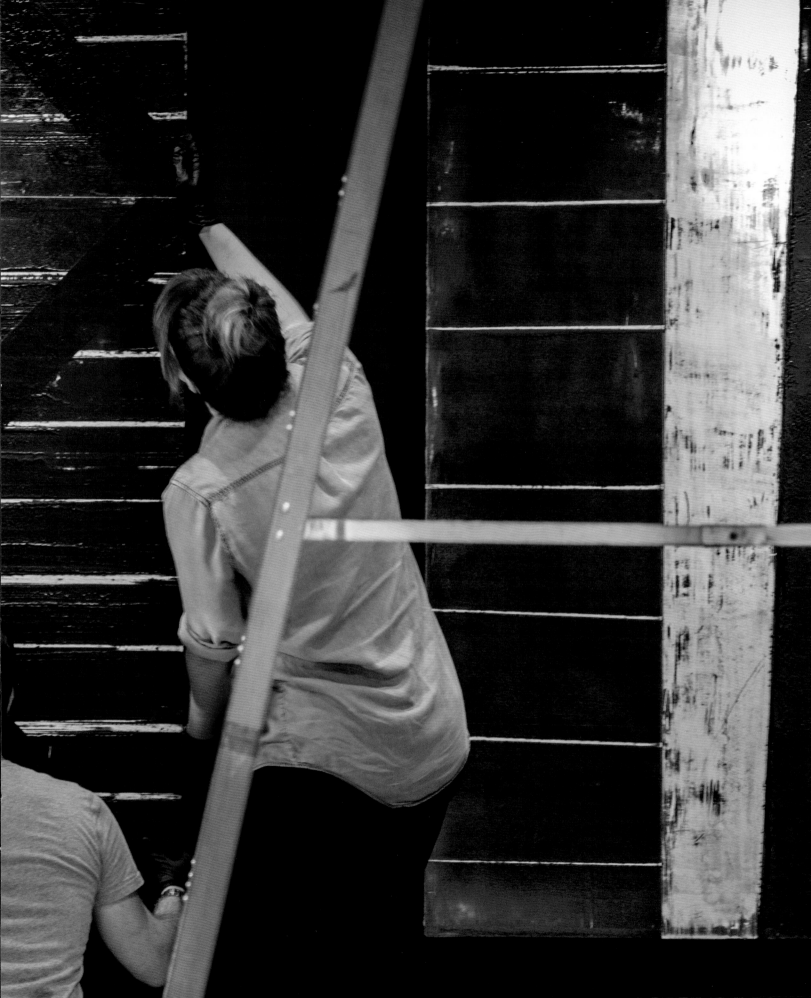

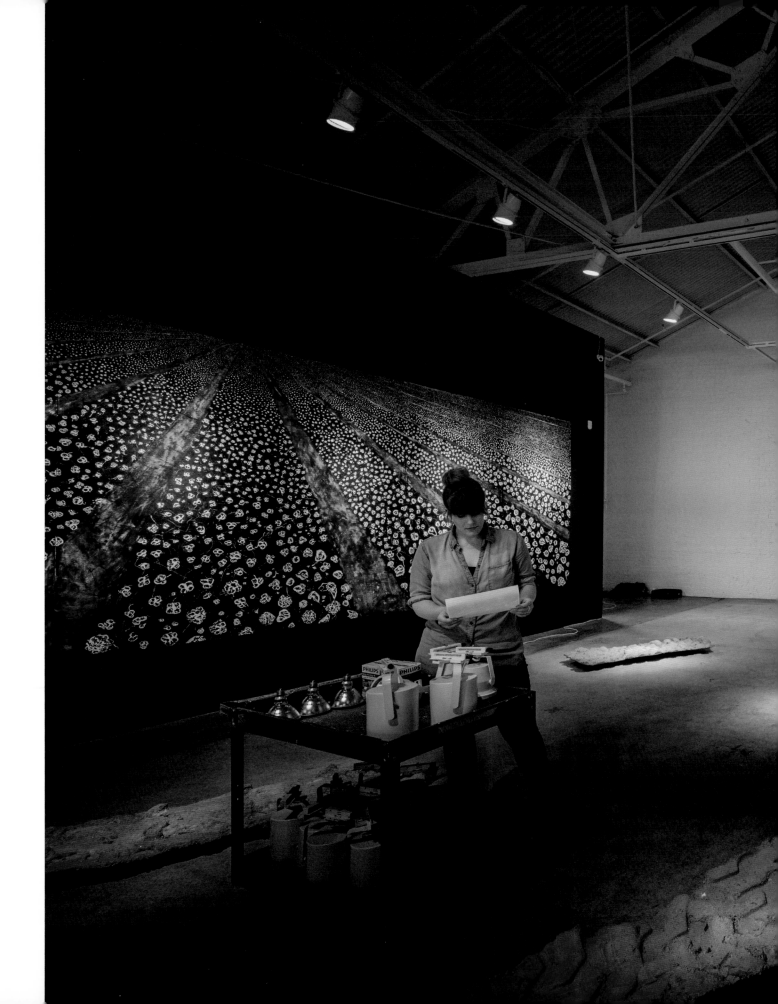

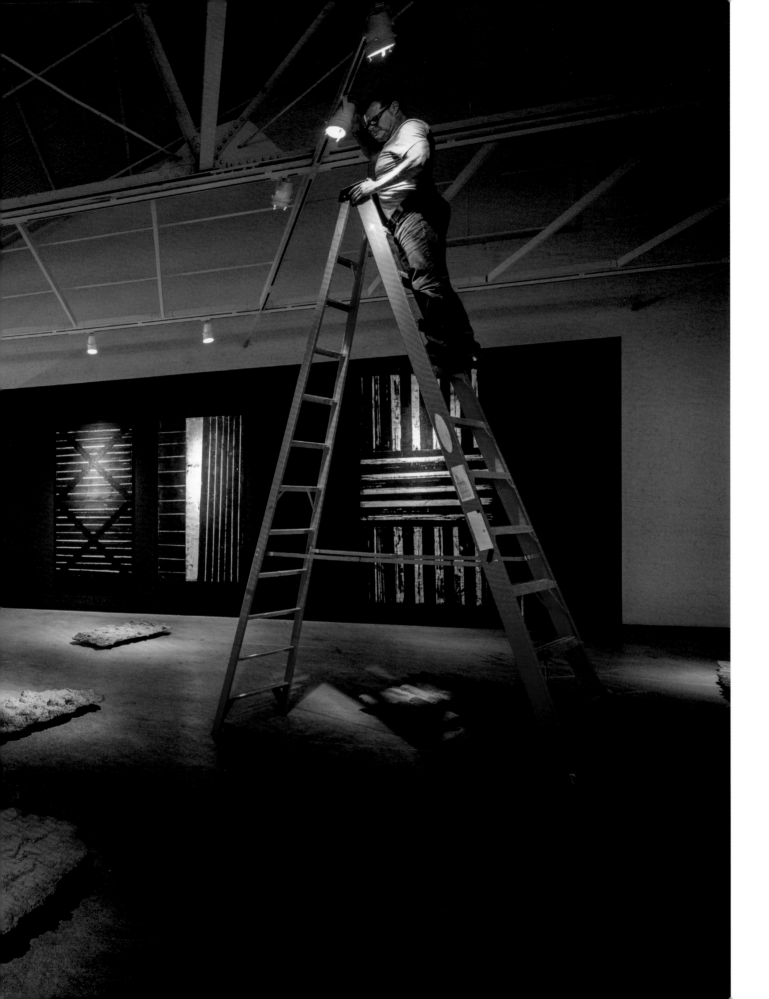

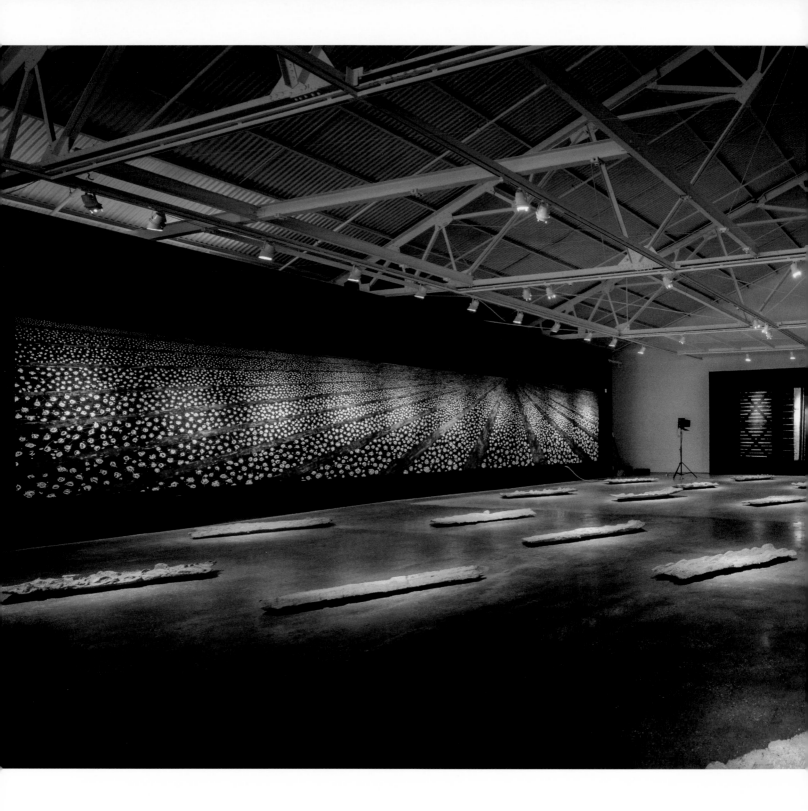

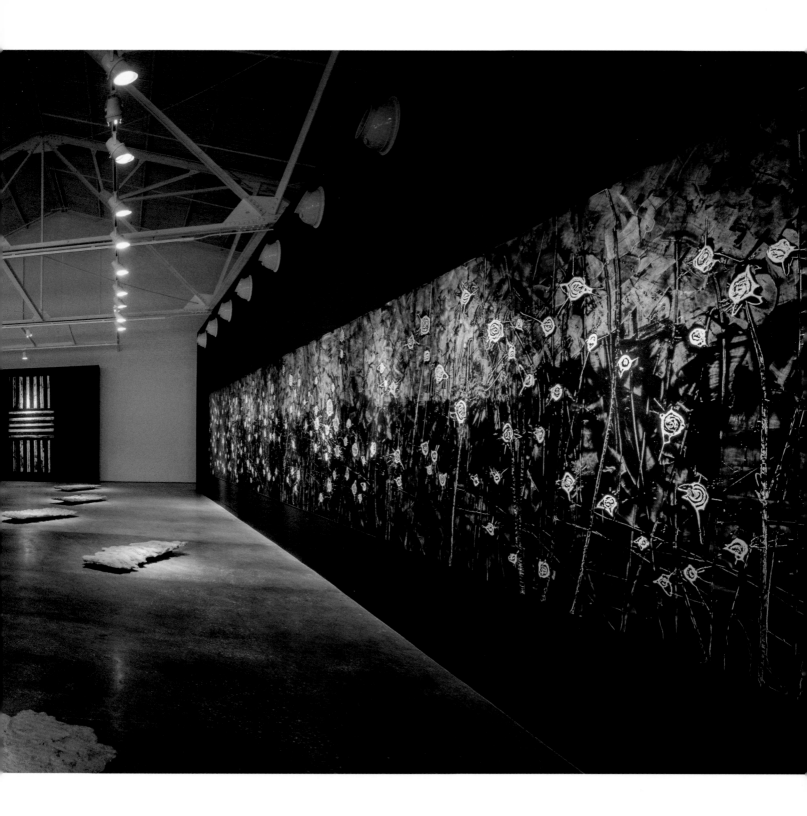

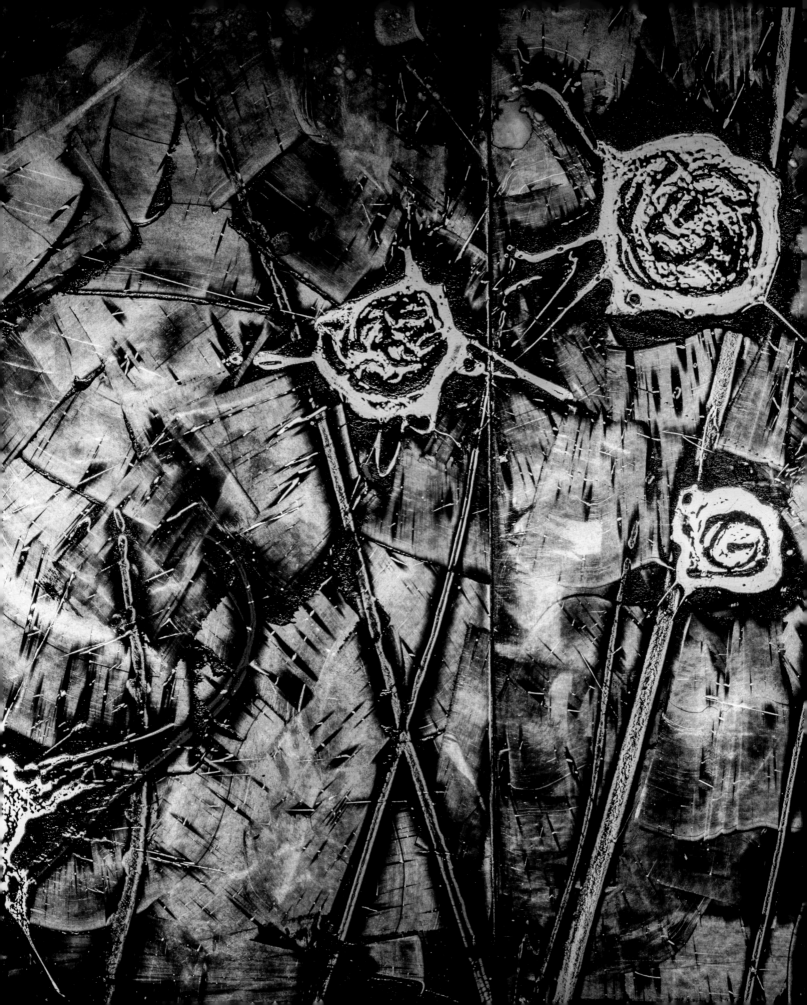

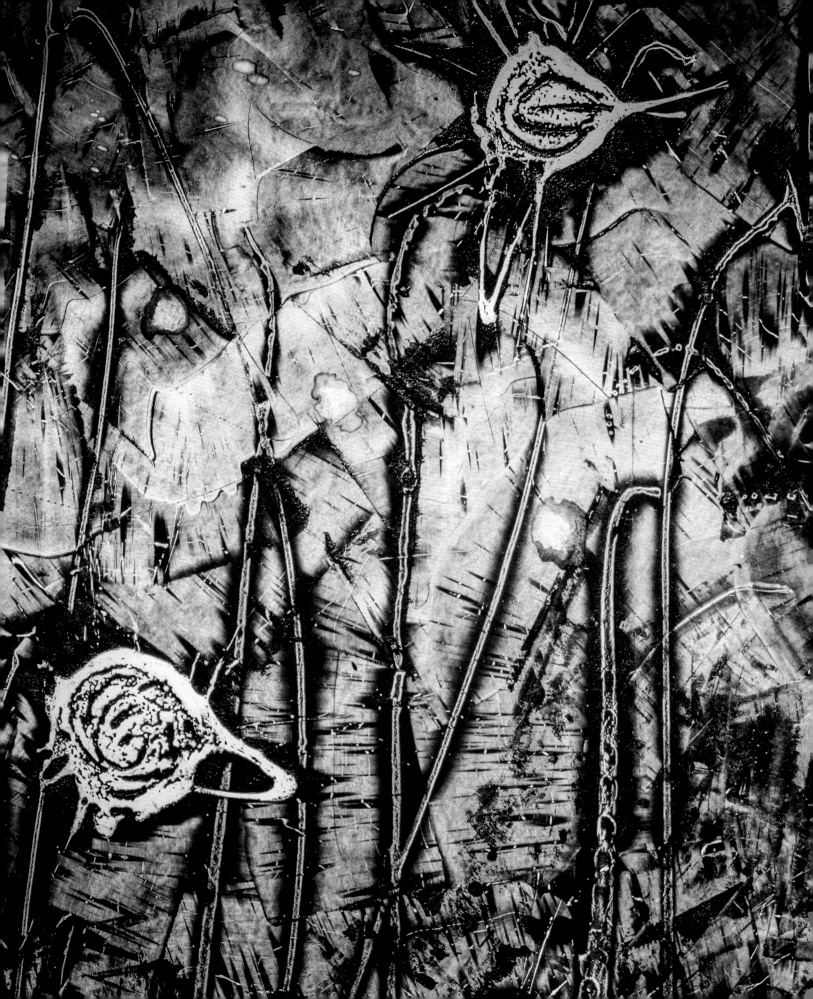

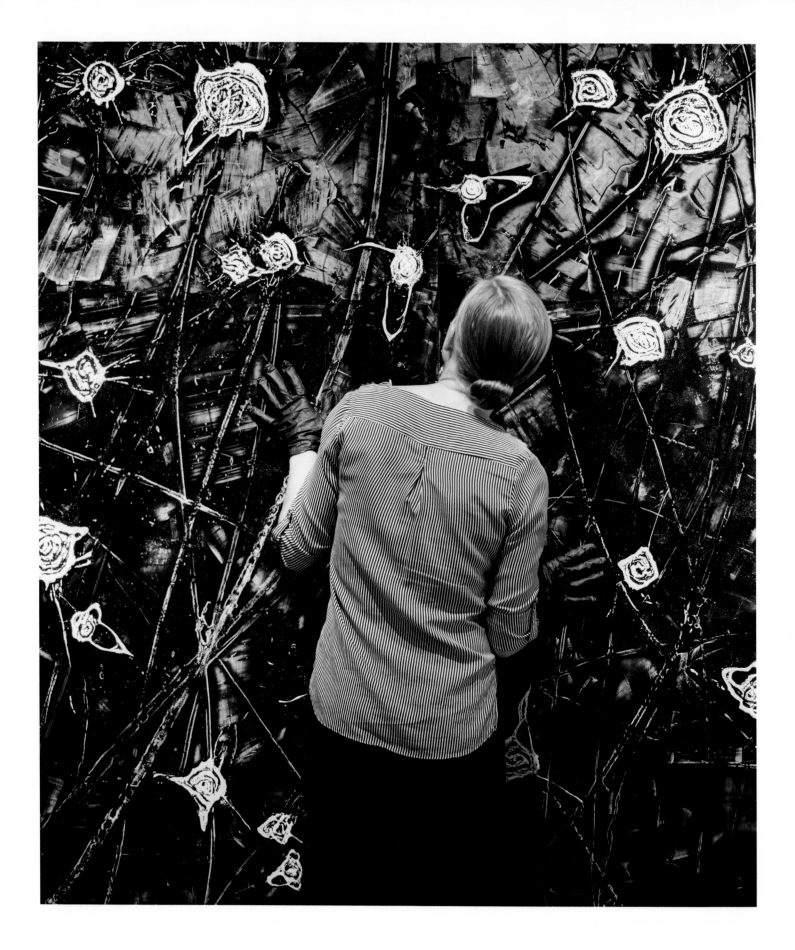

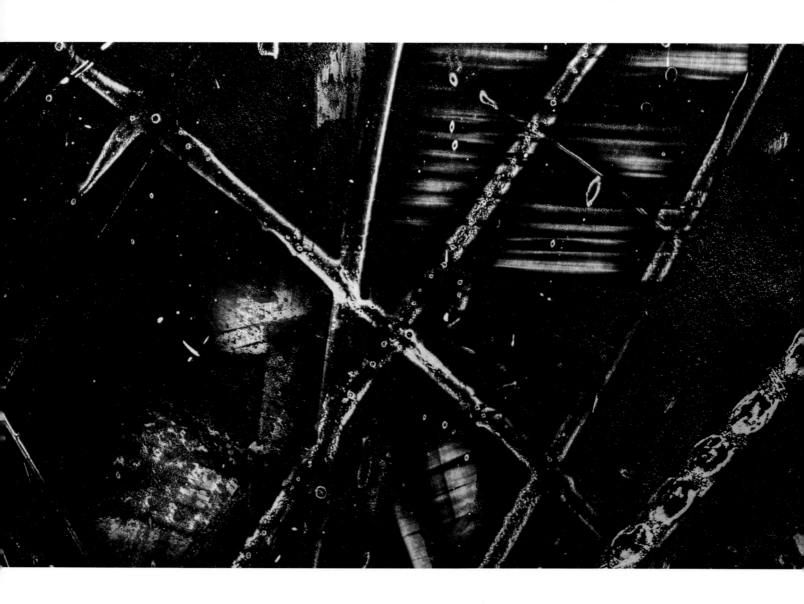

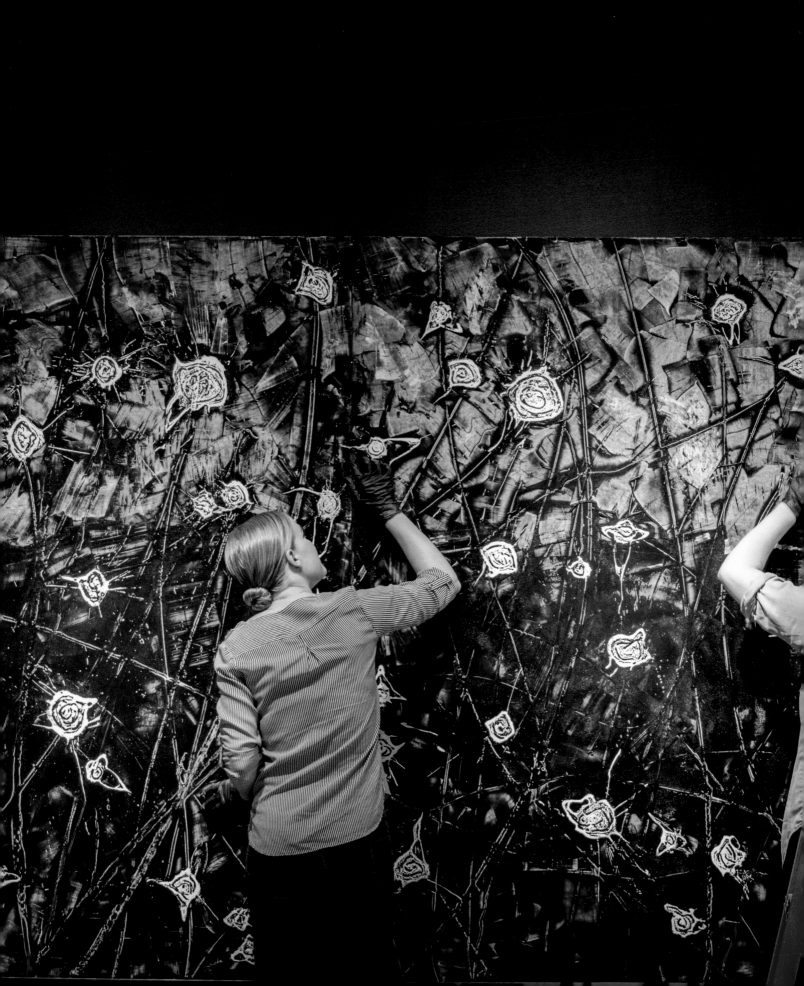

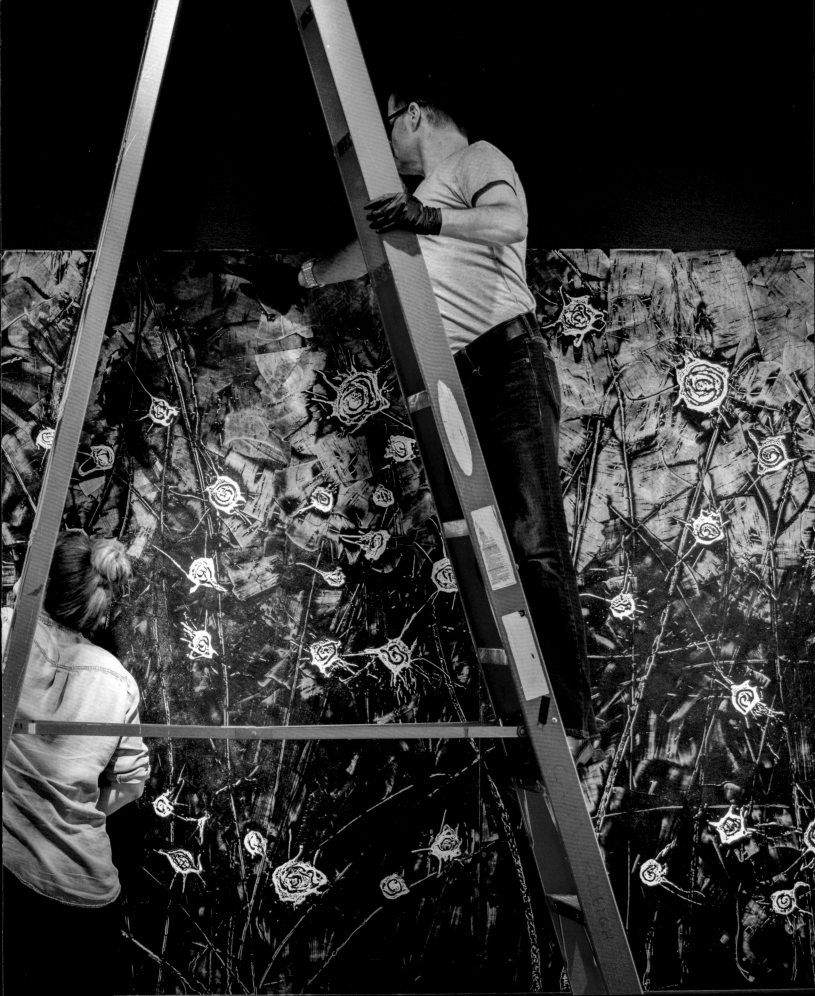

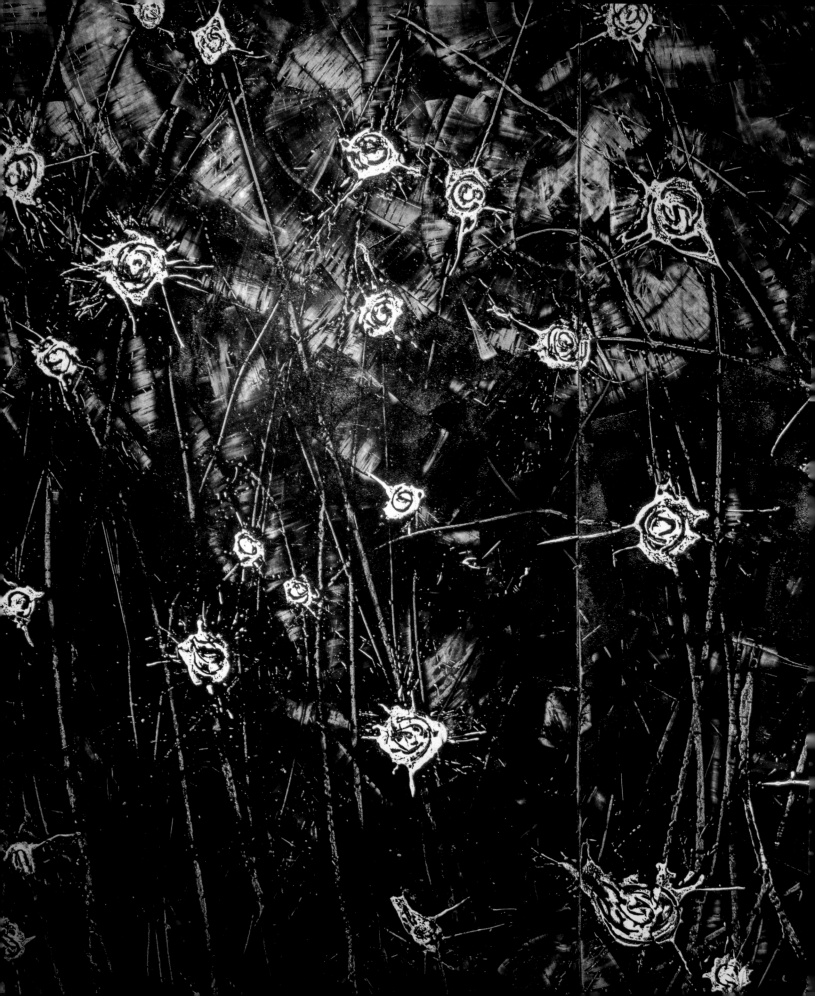

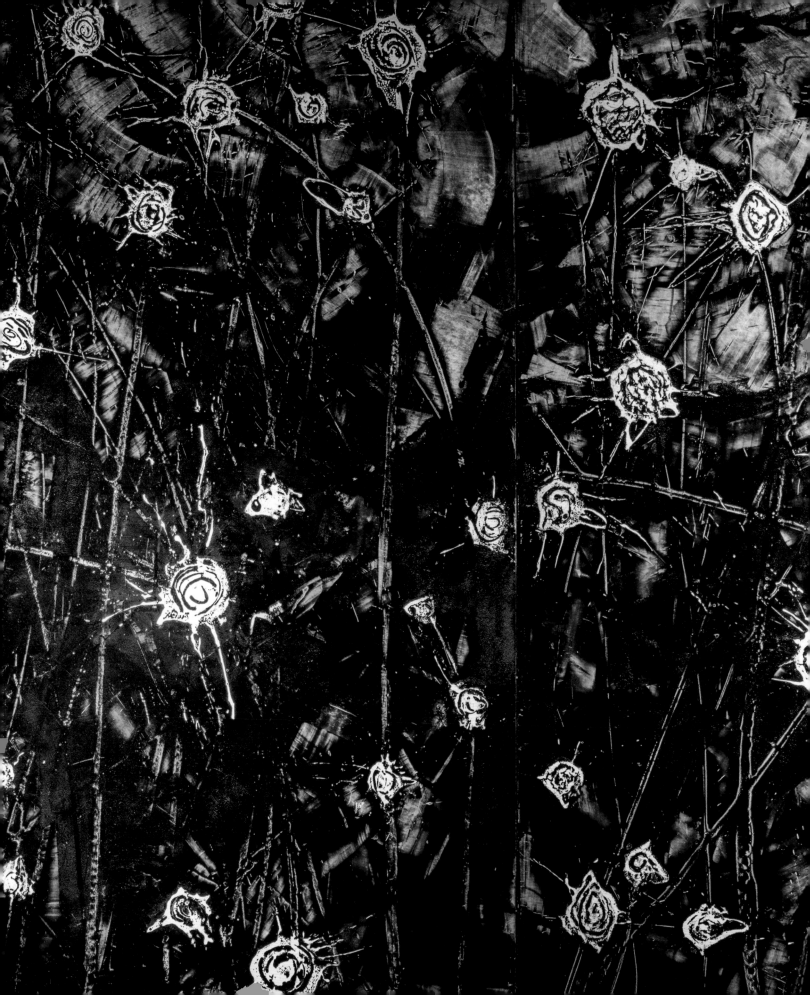

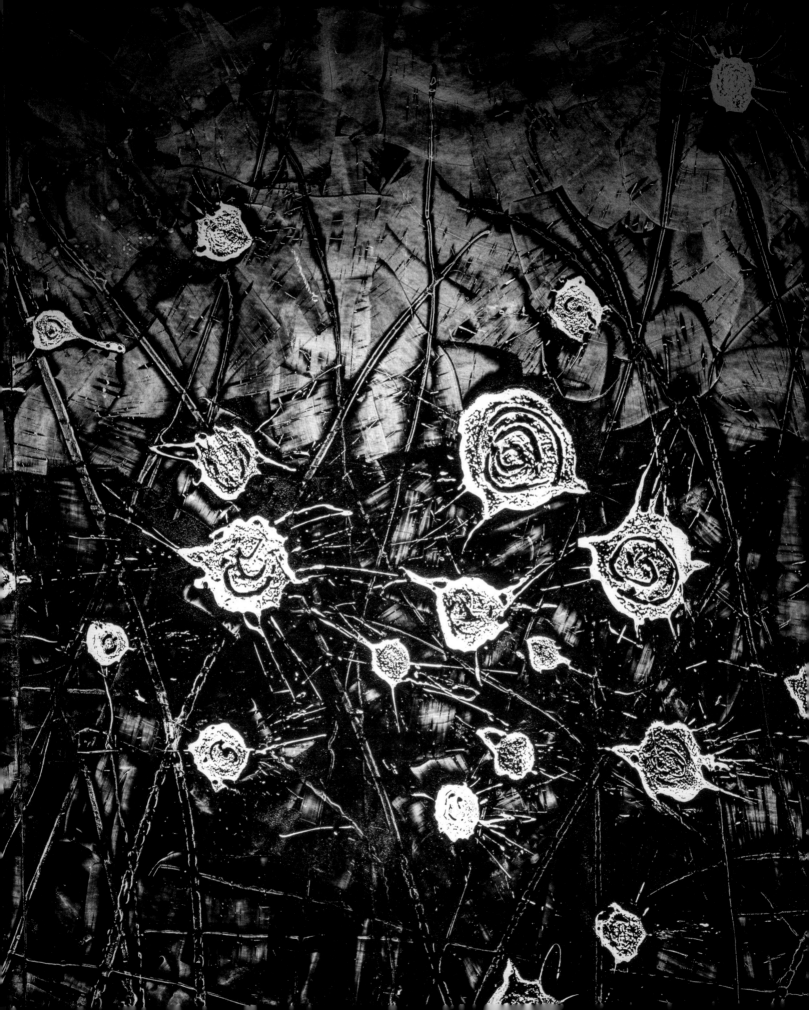

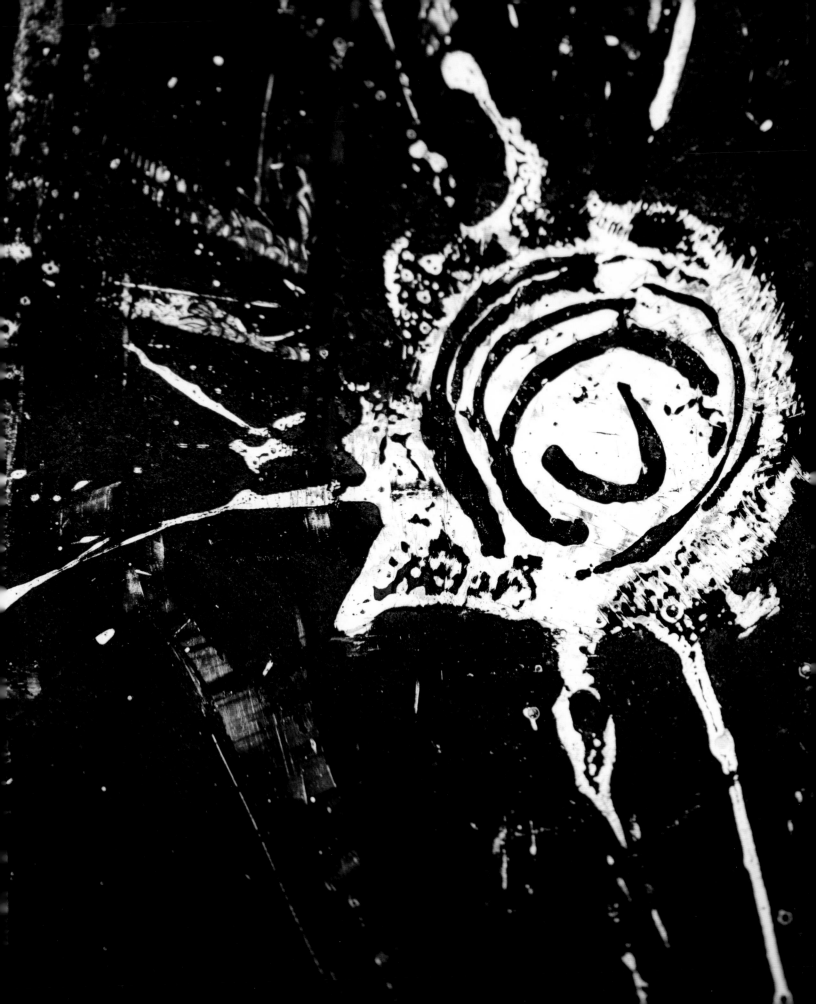

WHITE FLOWER

by *Howard L. Craft*

Like blank paper
Possibility lies within your center
Worlds within bulbs

With Gratitude

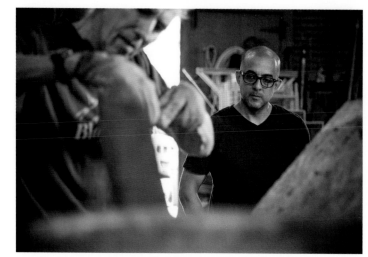

A special thanks to the poets and writers who took the time to visit the studio while *White Gold* was in process, to meet with Thomas Sayre, and to eloquently put your impressions into words for this catalogue.

CONTRIBUTORS

David Burris is a filmmaker, television producer, writer, and musician. A North Carolina native, Burris was raised in Raleigh and studied in Chapel Hill and Wake Forest. A founding member and songwriter in two bands that toured the US and Europe, he moved to LA in 1999 and became showrunner of the longrunning *Survivor* television series. He recently directed a feature film adaption of Ron Rash's *The World Made Straight* and is currently developing two film projects as well as a dramatic television series set in North Carolina's past.

Howard L. Craft is a poet and playwright in Durham, North Carolina. Craft also teaches writing in colleges, schools, arts centers, and other organizations throughout North Carolina. His work is commissioned by universities and professional theaters, published in poetry books and collections, and performed in the ongoing radio drama *Jade City Chronicles*, about African-American superhero Herald M.F. Jones.

David Dominguez is the author of the poetry collections *Work Done Right* (University of Arizona Press) and *The Ghost of César Chávez* (C&R Press). He is the co-founder and poetry editor of *The Packinghouse Review* and teaches writing at Reedley College.

Deidre S. Greben is an arts writer and editor in the New York City area and the former managing editor of *ARTnews* magazine. Her writing has been featured in *The New York Times*, *Smithsonian* magazine, and *Art + Auction* magazine, among others. She also writes scripts and edits projects for clients like the Guggenheim Museum and the Whitney Museum of American Art.

Art Howard is a Raleigh, North Carolina, native. As an Emmy Award-winning photographer, videographer, producer and director, he has worked with national broadcasters, nonprofit organizations, governmental agencies, and corporations around the country. His work has taken him to 7 continents and 53 countries.

Barbara Wiedemann is a designer, writer, and producer with roots in Germany, Canada, and New Jersey who calls North Carolina home. She's directed a university design program and spent many years coordinating design and publications for a nearby art museum before co-curating that museum's acclaimed Porsche design exhibition. Her firm, Design Story Works, oversaw the *White Gold* book project.

THE ARTIST WISHES TO THANK:

Joan-Ellen Deck
Wilson Sayre
Kalyan Sayre
Alan Scott
Aura Duggins
Bang Le
Barry Sullivan
Blaine Janas
Christian Karkow
Craig McDuffie
Diana King
Donna Campbell
Eliza Kraft Olander
Elizabeth Sterling
Farnum Brown
Gene Cole
Georgann Eubanks
James McKelvey
Jason Craighead
Jessie Sayre Maeck

John Wall
Jon Zellweger
Josh Martin
Kim Curry Evans
Linda Noble
Mark Hewitt
Marty and Alan Finkel
Marvin Saltzman
Mary Anne Howard
Mary Regan
Matt Bullard
Pearce family
Ricky Pearce
Sally Bates
Stephen Hill
Steve Levitas
Steve Schuster
Tom Soles
Zak Weinberg

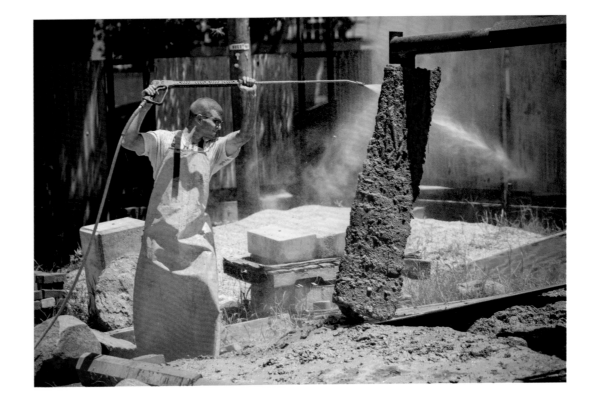

THE CAM TEAM

Gab Smith
Executive Director

Eric Gaard
Exhibitions Director

Melissa Roth
Associate Director of Operations

Nell Fortune-Greeley
Associate Director of Exhibitions

Mollie Earls
*Museum Educator + Gallery
Attendant*

Jeanny Sandoval
*Museum Educator + Gallery
Attendant*

Jaclyn Bowie
*Museum Educator + Gallery
Attendant*

Sydney Steen
*Museum Educator + Gallery
Attendant*

Rodney Oakley
Creative Consultant/Events

Tamar Harris Warren
Rental Events Manager

Tony Armento
Adjunct CFO

Gary Tedder
Art Handler

Mike Geary
Art Handler

Joe Kolliner
Art Handler

Nicole Smith
Designer

Margaret CeCe
Intern

Tatum Gephart
Intern

Linnea Heid
Intern

BOARD OF DIRECTORS

Charman Driver, Chair
Scott Bayzle, Vice Chair
Cailin Williams, Treasurer
Craig McDuffie, Secretary
Leah Goodnight Tyler, Executive
Committee at Large
Meredith Nelson, Executive
Committee at Large

Mariano Ballon
Dan Bryson
Tim Capps
Paul Coggins
Peter Duffley
Kim Elenez
Joyce Fitzpatrick
Debbie Hammersla
John Holmes
Andrea Hoyt
Andy May
Julie Paul
Kenneth Reiter
Steve Robinson
Martha Schneider
Susan Singer
Su Shearin
Joy Sloan
Allen Thomas Jr.
Sarah Yarborough
Smedes York
Nancy Benninger, CAM/now

Emeritus:
Carson Brice, Chair
Frank Thompson, Chair
Marvin Malecha

With gratitude:
Dillon Coleman
Keith Donahue
Bill Roberts
Naja Hines

WITH GRATITUDE:

AV Metro
AJ Fletcher Foundation
Alfred Williams & Company
Aloft Raleigh
Ann C. and C. Hamilton Sloan
 Family Foundation
Anonymous
Arts Access
Bank of America
Bhavana
Bida Manda Restaurant
Farnum Brown
CAM/now
Capitol Broadcasting Company
CE Rental
Celito
Cheryl Hazan Gallery
Ashley Christensen
Citrix
City of Raleigh Arts Commission
Clearscapes
Cotton Incorporated
Duke Energy Foundation
Worth Dunn
Ella Ann and Frank B. Holding
 Foundation
First Tennessee Bank
Flanders/Lump Gallery
Goodnight Educational
 Foundation
Grable Foundation
Tim Gupton and Brent Moore
Hobby Properties
Marjorie Hodges
IBM Community Grants
Kane Realty Corporation:
 The Dillon
Ross Lampe
Betsy and Steve Levitas
LS3P Associates
Lysaght Associates
Marvin J. Malecha, Dean, North
 Carolina State University
 College of Design (retired)
McConnell Studios
Elizabeth and Todd McGowan
Morningstar Law Group
Mother Earth Brewing
Newmark Grubb Knight Frank
Vansana Nolintha
North Carolina Arts Council,
 A Division of Natural and
 Cultural Resources
Parker Poe Adams & Bernstein
Pearce's Backhoe
Will Pearson, in honor of Marty
 and Alan Finkel

PNC Foundation
Elizabeth and John Purrington
Raleigh Denim Workshop
Rebus Works
Remedy Media
Robert P. Holding Foundation
Angela Salamanca, Centro
SiteLink
Sam Stephenson
Stewart
SunTrust Private Wealth
 Management and GenSpring
 Family Offices
Surevest
The Dreamville Foundation
The Honorable Nancy
 McFarlane, Mayor of Raleigh
The Pearce Family
The Umstead Hotel and Spa
The Wine Feed
Themeworks Creative
Thomas Law Group
Triangle Precision Painting

United Arts of Raleigh and
 Wake County
Videri Chocolate Factory
Wells Fargo
Larry Wheeler, Director, North
 Carolina Museum of Art
William R. Kenan Jr. Charitable
 Trust
Womble Carlyle Sandridge &
 Rice

CAM Raleigh is funded in part
 by the City of Raleigh based
 on recommendations of the
 Raleigh Arts Commission

The Betty Eichenberger Adams
 Society

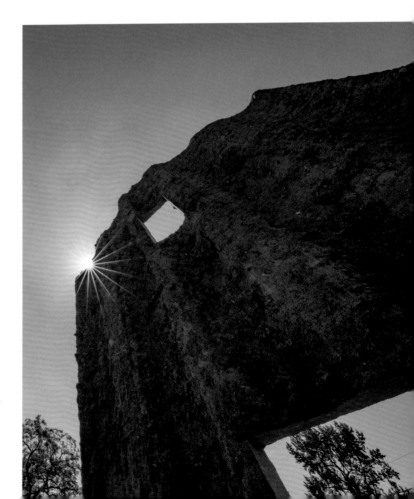

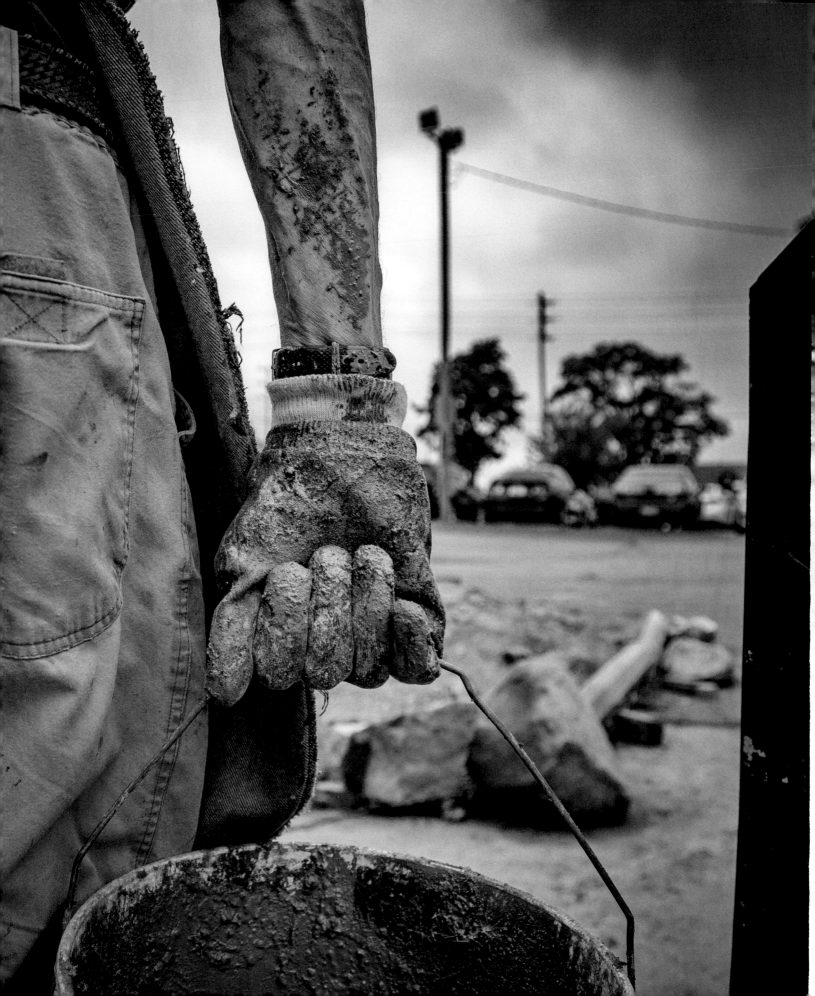